Calligraphy Tips

Other books by Bill Gray

Studio Tips

More Studio Tips

Lettering Tips

Tips On Type

Calligraphy Tips

Bill Gray

UNWIN
PAPERBACKS

LONDON SYDNEY WELLINGTON

First published in Great Britain in paperback by Unwin® Paperbacks, an imprint of Unwin Hyman Limited, in 1989.

First published in the United States of America by Design Press.

Unwin Hyman Limited
15-17 Broadwick Street
London W1V 1FP

Allen & Unwin Australia Pty Ltd
8 Napier Street, North Sydney, NSW 2060, Australia

Allen & Unwin, New Zealand Pty Ltd with the Port Nicholson Press
9th floor, Compusales Building, 75 Ghuznee Street, Wellington 1, New Zealand

British Library Cataloging in Publication Data

Gray, Bill
 Calligraphy tips.
 1. Lettering & calligraphy
 I. Title
 745.6'1

ISBN 0-04-440485-9

Printed in the United States of America

Acknowledgments

The designers of the classic Roman capitals on the inscription on the Trajan column in Rome (A.D. 113) gave us the model from which all of our calligraphic letter styles developed. In the centuries that followed, master craftsmen, scribes in monasteries, and great designers of letterforms, have created the variety of written styles we have today. We recognize, with thanks, their contributions.

Recognition and thanks are also given to those dedicated workers in calligraphic societies all over the world who organize workshops, publish helpful newsletters and quarterlies, share information, and help to keep the spirit of the gentle art of calligraphy alive.

In the preparation of this book, thanks is also given to the following for their help: James Hayes for page 26, Pat Buttice for page 29, Allen Q. Wong for page 12, Sam Millet for page 43, Al Zanetti, Terri Ewell, Tom Anderson, Maureen Squires, Jon and Tim Gray, Jesse Hulse, Leona Kaufman, Sandy Glass, Sandra Forrest, Richard B. Walsh, Mary Hopkins, and Pat Kennedy.

"Anyone who is fascinated by and practices calligraphy will never be bored with life."

HERMANN ZAPF, CONTEMPORARY DESIGNER

Preface

Models of major calligraphic styles are shown with the appropriate ductus (demonstration of sequence and direction of strokes) and copies of each original writing, as it was first written, are shown. Studying them will help you get the "feel" of the style. Common errors that beginners make are shown, as are allowable variations of form.

The models shown for you to copy are actually modifications of the original writing. In the days of manuscript writing, the scribes in the scriptoriums often took liberties while copying a model alphabet, and this resulted in many variations of style. There is rarely just one perfect model for studying a style.

Because of space limitations, exhaustive explanations and descriptions are limited here. An excellent list of references to give further illumination will be found in the Bibliography. If your pocketbook prohibits purchasing the books, visit a library, and, if the library does not have the book you are looking for, it may be able to get it for you. Perhaps a fellow calligrapher has a book you can borrow. Sharing your information is part of being a calligrapher.

Many references to dates are approximate, and many rules are given, but few are absolute.

Most calligraphers favor styles they like best, but the aim here is to make you familiar with all styles.

Contents

"Calligraphy: Disciplined freedom is the Essence of it."

Introduction

"Calligraphy" means beautiful writing. The word comes from the combining of two Greek words, **kallos** (beautiful) and **graphos** (writing). To write calligraphy one must learn and practice the following disciplines:

1. How to <u>form</u> the major writing styles.
2. How to <u>space</u> the letters, words, and lines.
3. How to use the <u>tools</u> that form the letters.
4. How to <u>arrange</u> the writing most effectively in a design.

As is true for any form of writing, practicing these disciplines will result in the development of a personal style. Banks and other institutions accept signatures on checks and other documents as proof of identity because they recognize that no two people write in exactly the same style.

The process of learning calligraphy is a self-motivating one. As you learn and practice the disciplines and your results improve, you will want to do more.

Legibility should always be a goal. Writing illegibly solely for artistic effect is something you can save for later.

The purpose of this book is not to display the virtuosity (if any) of the author, but rather to demonstrate the disciplines listed above. Other related information is given to make the beginner's calligraphic effort easier. I suggest that you inspect the entire book before attempting to write the styles — there may be information that will help at the beginning.

Note : Please read the section, **Safety Precautions**, which begins on page 114, before starting to work.

8

"The true beginning of life is writing."

GREEK WAX TABLET, FOURTH OR FIFTH CENTURY

In the Beginning

Before writing was invented, methods of keeping records or communicating ideas were limited to such crude devices as cutting notches on wooden sticks, writing marks on stones,

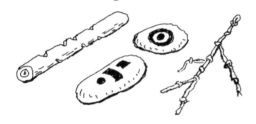

and tying knots on string. As far as we know today, prior to its invention, there was no such ordered system of combining symbols to accomplish this purpose. Learned authorities claim that it was the invention of writing that marked the beginning of civilization.

The earliest system of writing was invented by the Sumerians around 3500 B.C. in an area between the Tigris and Euphrates rivers in what is now Iraq. They used a triangular-tipped stylus to impress their alphabet symbols on wet clay tablets, which were then baked to

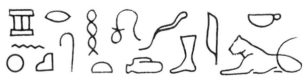

harden either in the sun or in ovens. This system is called "cuneiform" (wedge-shaped).

A short time later, the Egyptians created another system called "hieroglyphics" (sacred carvings), in which picture symbols were carved in stone. Their symbols were

simplified later into a written form called "hieratic" (sacred writing), and still later into a still simpler form called

"demotic" (of the people) script. The system was called "pictographic."

Hieroglyph for SCRIBE

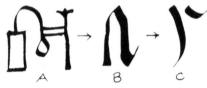

Later simplified written forms.
A. Hieroglyphic manuscript
B. Hieratic script
C. Demotic script

Around 1500 B.C., the Phoenicians, a Semitic people from the northern part of the eastern Mediterranean area, invented an alphabet that became the root of most of our western alphabets in use today. This was the first alphabet in which the symbol represented sounds made by the human voice. The first known "phonetic alphabet," it is shown to the right.

PHOENICIAN NORTH SEMITIC	EARLY GREEK	ETRUSCAN	ROMAN CAPS
∀	◁	A	A
9	8		B
↑	٦	>	C
◁	△		D
Ⅎ	∃	∃	E
Y	ϟ	ⅎ	F
			G
I	I	∓	
⊟	⊟	⊟	H
⊗	⊗	⊙	
Z	⟨	l	I
		17TH CENT. →	J
Ƴ	⋊	⋊	K
∟	↑	⌐	L
ϻ	ϻ	ϻ	M
५	५	५	N
⧻	⫴	⋈	
O	O		O
٦	٦	↑	P
⋔	M	M	
φ	φ	Q	Q
4	4	4	R
W	५	५	S
X	X	✝	T
		V	U

V, W, X, Y, Z AND G
WERE DERIVED FROM
EARLIER LATIN ALPHABETS

Other writing systems and styles are shown below, but our concern in this book is with the Latin Roman alphabet, which we use today.

גְּלִיצִינִי וְאַבִּיטָה נִפְלָאוֹת

Hebrew

امريكا مصر سوريّا لبنان العراق

Arabic

Diese Schrift heißt die deutsche Schrift

German Script

Обладите куском Нью-Йорка

Russian

North American Indian

11

Seal Script
(CHUAN·SHU)

Clerical Script
(LI·SHU)

Regular Standard Script
(KAI·SHU)

Grass Script
(TS'AO·SHU)

Shortly afterward, the Greeks borrowed most of the Phoenician letters for their language and called the letters

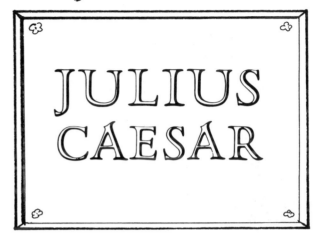

EARLY GREEK LETTERS 7TH CENTURY B.C.

names derived from the Semitic names. Thus, Alef (A) became Alpha, Beth (B) became Beta, Daleth (D) became Delta, and so on.

The Etruscans, traveling from the Far East through Greece, finally settled in northern Italy and borrowed many of the letters for their language from the Greeks. At about this time (400-500 B.C.) the Roman Empire was developing. The Romans adopted many of the Etruscan and Greek letters to form their own alphabet for their language—Latin. They added G, Y, and Z, but it was not the complete alphabet of twenty-six letters as we know it today. J, U, and W were added centuries later to make

the twenty-six. The Roman alphabet was used mostly for carving memorials and the

JULIUS CAESAR

like in stone. A cursive written form, representing the capitals, was used for everyday writing and was written on wax

Small-letter cursive writing — Rome, third century.

tablets with a stylus. It had great influence much later in the development of small, or minuscule, letters.

SENATVSPOPVLVSQVEROMANVS
IMPCAESARIDIVINERVAEFNERVAE
TRAIANOAVGGERMDACICOPONTIF
MAXIMOTRIBPOTXVIIIMPVICOSVIPP
ADDECLARANDVMQVANTAEALTITVDINIS
MONSETLOCVSIANT⎱⎰EIBVSSITEGESTVS

Roman Capitals

Most authorities agree that the Roman letters reached a state of perfection on the inscription below the Trajan column in Rome, made in about A.D. 113. A linear representation of these letters is shown above. All scribes should learn the proportions of these beautiful letters. The letters were first designed with a flat-edged tool held at a constant angle of 30 degrees with a horizontal line.

The angle changed for a few strokes (N). Some strokes are heavy and are called "stems." Others are thin and are called "hairlines." Serifs were added to the ends of most strokes, which added a decorative feature to the letters and helped in aligning them.

The classic roman capital (MAJUSCULE) is the mother of all our calligraphic styles. This form is also called old style.

The diagram above is an
aid to help you learn the
proportions of the Trajan
letters. Lay tracing paper over
it and draw the skeletons,
as shown on the next pages.
 The round figure is not a
circle, but a fat ellipse whose
width is less than its height.
The height is 8 pen widths,
making it 2 ¼ inches using
a ¼-inch marker. Divide
the width into 8 equal parts.
Draw a heavy line halfway
from top to bottom and
another heavy line vertically
to divide the figure from
left to right.

Carefully observe where all the letter parts begin and end. Draw the entire alphabet as in 1, above right. Next, write the letters as in 2, below left, holding the flat-edged pen at a consistent angle of about **30** degrees, except where noted. The suggested pen to use is a flat-edged 1/4-inch marker pen. Finally, add the serifs and other parts with a smaller pen, as shown in 3, below right.

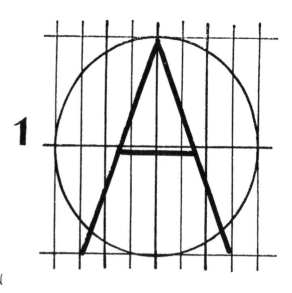

1

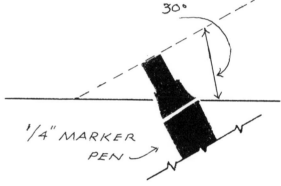

30°

'/4" MARKER PEN

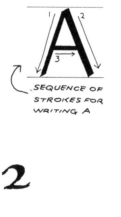

SEQUENCE OF STROKES FOR WRITING A

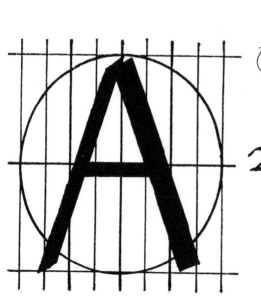

2

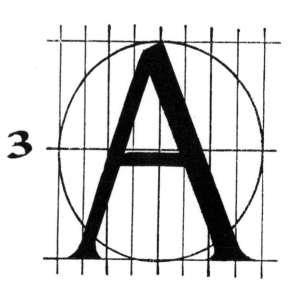

3

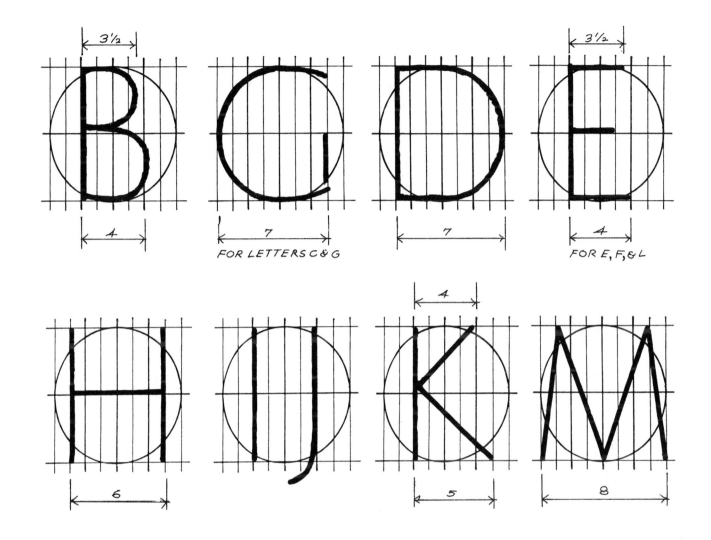

Roman Skeletons

The letters shown above are smaller than the learning aid to save space, but you should write them the same size as the learning aid on page 15. The widths of letters are shown in one-eighth units. Note where crossbars occur. These widths do not include serifs. Write the alphabet 2¼ inches high.

17

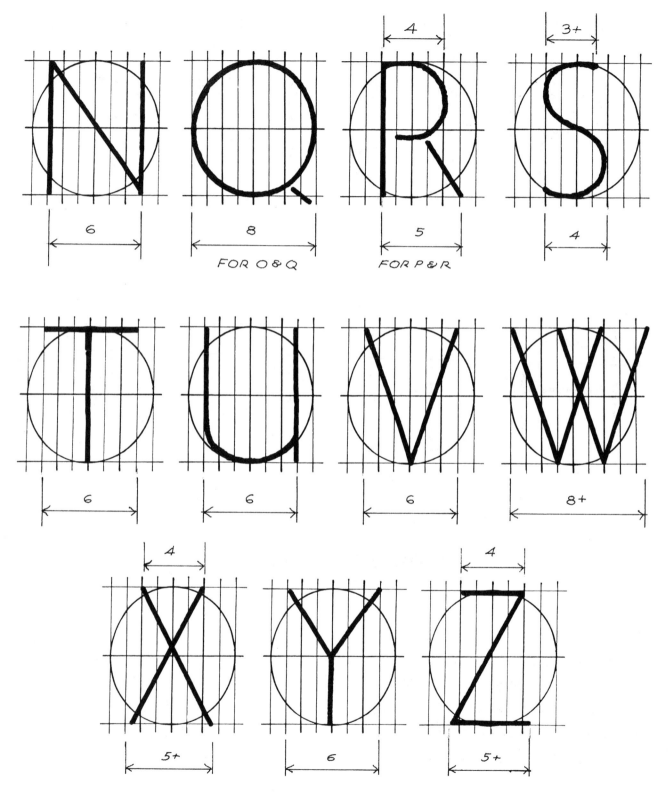

FOR O & Q

FOR P & R

18

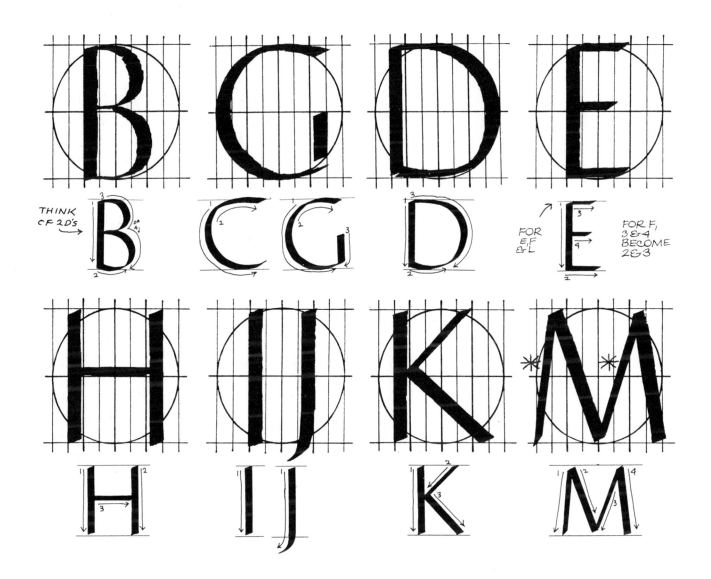

THINK OF 2 D's →

FOR E, F & L

FOR F, 3 & 4 BECOME 2 & 3

Roman Structures

Holding the ¼-inch marker at a 30-degree (approximate) angle, now draw the structures of letters over the skeletons you have practiced. Change the angle of the pen for some strokes (marked with ✳). Stroke sequence is shown with small numbers. Do not write beyond the widths of the skeletons. Keep all parts within the skeletons.

19

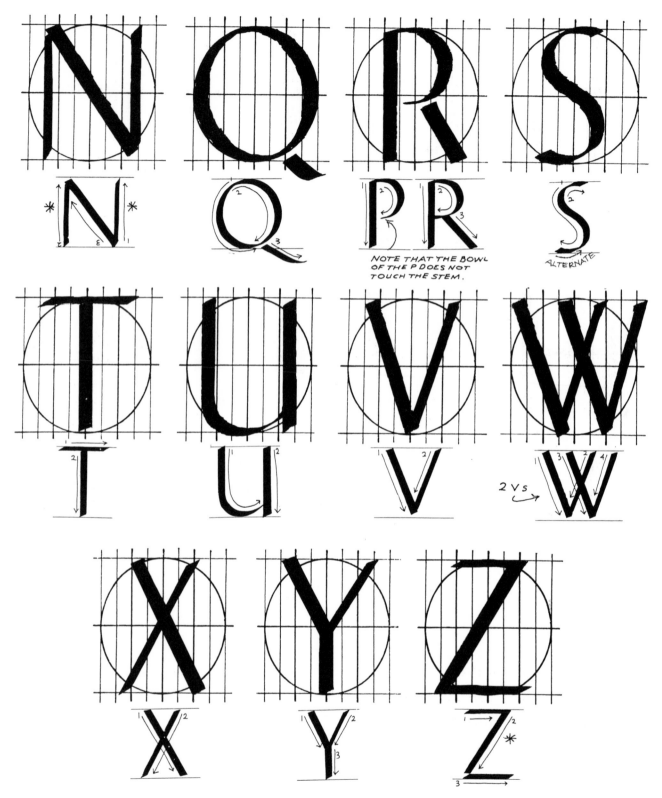

NOTE THAT THE BOWL
OF THE P DOES NOT
TOUCH THE STEM.

ALTERNATE

2 Vs

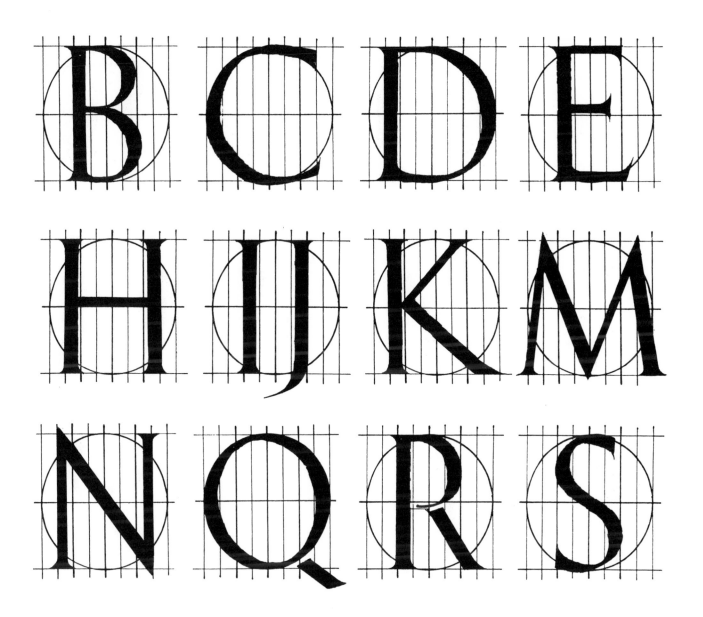

Finished Written Letters

Using any tool (pointed or smaller flat-edged pen), draw serifs, points at tops of A, M, and N, bottoms of M, N, V, and W, and other refinements. These letters lack many of the subtle refinements of Trajan letters. They are written here to show basic construction and proportions only.

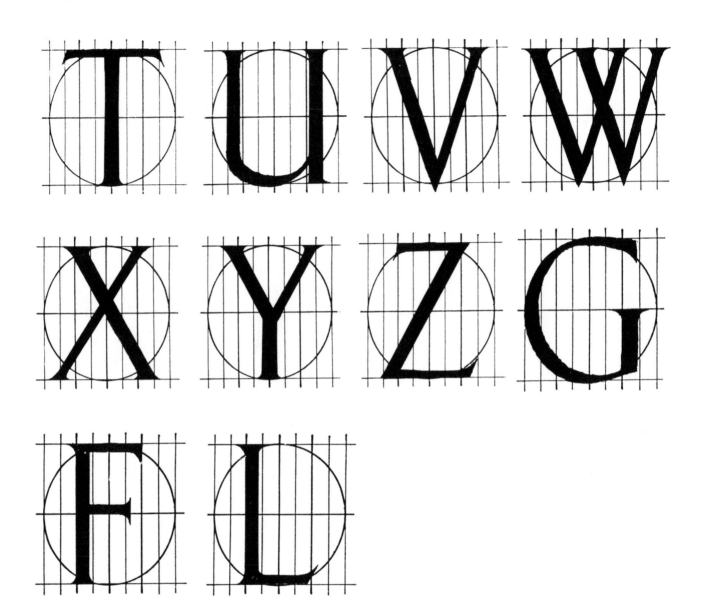

22

Notes on writing roman capital letters

Method of finding 30-degree pen angle for writing classic roman letters.

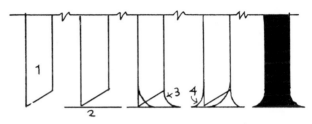

Sequence of strokes when writing serifs.

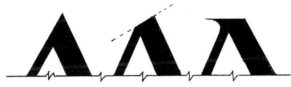

Optional tops of A. If the A has a pointed top, the tops of M and N are also pointed. Bottoms of M, N, V, and W are always pointed.

ABCEFG
HLMWS

Skeletons of roman capitals showing common errors. Crossbar of A is too high, lower bowl of B is too large, top and bottom curves of C should be flatter, middle arm of E should be lower, the bottom arm of F should be higher, middle of G is too high, crossbar of H is too high, foot of L is too long, points of middle Vs of M and W should touch guide lines, and top void of S must be smaller than bottom void.

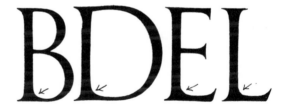

The inside bottoms of these letters have a slight bracket from hairline to stem,* but never at the top inside. * ARROWS

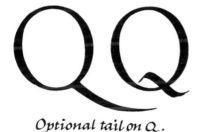

Optional tail on Q.

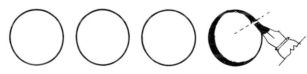

Practice writing O s by first drawing many circles with a compass. Then, using a flat-edged pen, at a 30°angle, write O s inside them.

AG

All pointed and curved parts of letters should extend slightly beyond the guide lines.

N

Pen angle changes for some strokes (verticals and diagonal) as in the letter N to make the strokes compatible with others.

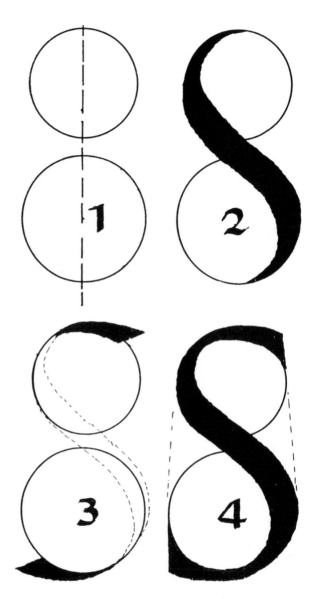

The above will help you when writing the letter S. Think of two circles centered on each other. The top circle is slightly smaller than the one under it (1.). Write the spine (2). Add flat curves, top and bottom (3). Finish by drawing the serifs as shown (4) with a smaller pen.

Variations of the above.

PRAETEREATAMSVNTARCIVRISIE
HAEDORVMQ.DIESSERVANDIE
QVAMQVIB·INPATRIAMVENTO
PONTVSETOSTRIFERIFAVCESTEM
LIBRADIESOMNIQ.PARESVBIFE
ETMEDIVMIVCIATQ·VMBRISIAI

Quadrata

The first pen-written roman capitals were called "quadrata," or square capitals. As a style, quadrata was short-lived. The only true examples of it, written in the fourth century, are fragments of the works of Virgil. They are very difficult letters to write. The sample above is part of a Virgil page and was probably written with a flat-edged reed pen on vellum (calf skin), with the flat edge about parallel to a horizontal base line. For some letters, the pen was turned for thin strokes. The style, quadrata, was revived in Renaissance manuscripts for titles, and probably influenced scribes designing humanistic capitals (see page 47).

Cursive capitals written with a stylus on wax tablets at the time of quadrata.

It reads from left to right: EGARETUR EX-ACTE CUTEX ANTENTI OS ECUNDUM OU.

ABCDEFGHIKLMNOPQRSTVXYZ

Rustic Capitals

Rapidly written rustic capitals, as in the example above, were painted with a flat-edged brush on the walls of buildings for public notices. The letters are condensed and require much tool manipulation. The tool is held so that the flat edge is almost vertical, which results in thin vertical strokes and distinctive heavy parts at top and bottom of letters. Rustic capitals were also written with reed pens. The letters were probably condensed to get more on a line, thus saving expensive vellum and parchment.

The alphabet below is James Hayes's version of a fifth-century rustic. Below that is a modern version created by Mr. Hayes.

Written rustic capitals were not used much after the fifth century.

ABCDEFGHIJKLMNOPQRSTVWXYZ

5TH CENTURY

ABCDEFGHIJKLMNOPQRSTUVWXYZ

MODERN VERSION

Jim Hayes is an outstanding American calligrapher and graphic designer who resides in Colorado. The alphabets here are reproduced with his kind permission.

TESSTULTIFACTI B
SUNTETMUTAU D
RUNTGLORIAM

Enlarged uncial capitals from a fragment of a fourth-century manuscript.

Uncials

Roman uncial letters were introduced sometime in the fourth century and quickly spread throughout the entire Roman Empire. The forms were modifications of earlier Greek uncials. With the concurrent rise of Christianity, uncial (pronounced un-she-al) became a Bible script and was used primarily for religious writings.

Uncial is a simple majuscule letter, quickly written compared to other styles. For the first time, parts of some letters were written above and below the guidelines. It has no serifs, is a wide letter, and, consequently, has larger voids. To write uncial, the flat edge of the pen is held almost parallel to the baseline and, wherever possible, the letters are written without lifting the pen.

Individual letters were often used as large capitals at paragraph beginnings, and, as such, Roman uncial letters were used with other text styles. It was used for subtitles in the Carolingian period. Letter spacing was tight, but line spacing was generous.

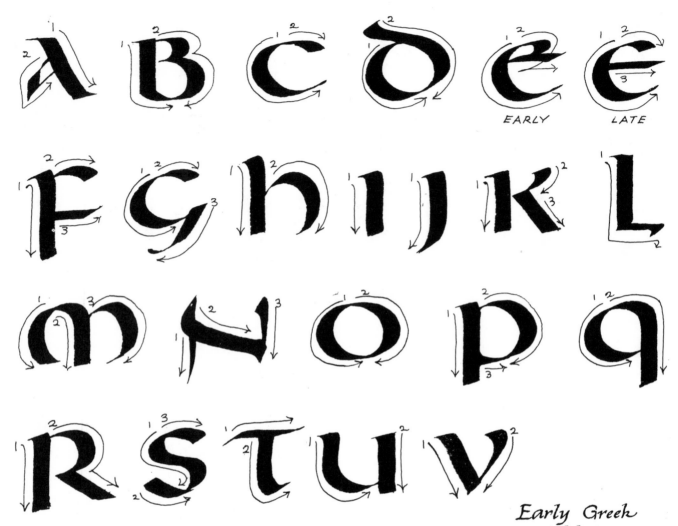

A B C D E E E

EARLY LATE

F G H I J K L

M N O P Q

R S T U V

W X Y Z

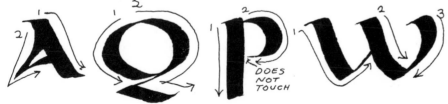

Early Greek uncial letters

ΑΠΟΠΡΟ
ΟΤΙΚϹΟ
ΘϹΕΝΟ
ΚΑΙΕΠΙΓ
ΚΑΙΝΥΝ
ΜΟΙΚΝΤ

A Q P W

DOES
NOT
TOUCH

TWIST

28

(rows of hand-drawn uncial letter "a" variations)

ALL OF THESE UNCIAL
LETTERS ARE FREELY
WRITTEN ADAPTATIONS
OF ACTUAL HISTORIC FORMS.

All calligraphers use models of all styles for
study. This page shows the variations of one
model (uncial) that were due to the personal
interpretation of the scribes who wrote them.
If every calligrapher wrote letters exactly
like those in a model, all the writing
would look the same.

The examples on this page
were written by Patricia Buttice,
an outstanding New York
calligrapher, and are reproduced
with her kind permission.

Insular
half-uncials

erat incipiens quasi ali
ut utputubatur filius

Half-Uncials

The development of half-uncial as a writing style was influenced by Roman cursive writing as much as anything else. It is a minuscule (small letter) compared to uncial, which, like roman capitals, square capitals, and rustica, are majuscule (large letters). In time, along with Carolingian minuscule (see page 33), it contributed greatly to the development of what is called "lowercase" lettering in type. Many of the letters have ascenders and descenders.

Half-uncial was used primarily for religious writings. It is sometimes called "demi-" or "semi-uncial." It is written with the flat edge of the pen held almost parallel to the baseline. In the fifth century another form of uncial was the quarter-uncial, which looked like Roman cursive writing and was very hard to read. It never became popular as a writing style.

a b c d e f

g h i j k l m

n o p q r s

t u v w x y

z

Some alternate letters, in smaller scale, are shown below.

d e e f g g

k p w y y y u z

31

abcdefghi
klmnopqr
stuvwxyz

Shown above is an alphabet of insular half-uncials. The sequence and direction of strokes are similar to the half-uncial on the previous page.

Below is an experimental alphabet of slanted uncial majuscules.

ABCDEFGHI
JKLMNOPQ
RSTUVWXYZ

autem . genuit Naasson ; Naasson autem . genu
it salmon · Salmon autem . genuit booz dera
chab ; Booz autem . genuit obed exruth · Obed
autem . genuit iesse ; Iesse autem . genuit da
uid regem ; Dauid autem rex . genuit salomo
nem excea quaefuit uriae ; Salomon autem .
genuit roboam · Roboam autem . genuit abia ;
Abia autem . genuit asa · Asa autem . genuit
iosaphat ; Iosaphat autem . genuit iora · Iora
autem . genuit oziam ; Ozias autem . genuit

Carolingian minuscule writing above is an enlarged section of folio F69, M191, shown here with permission of The Pierpont Morgan Library in N.Y.C.

Carolingian Minuscule

In France, near the end of the eighth century, Emperor Charlemagne caused a revival of classic learning. He brought the learned English cleric-scholar, Alcuin, from England to improve on manuscript writing, which had deteriorated to a sorry state after the fall of Rome. As a result, at Tours, France, Alcuin created a writing style that is called "Carolingian minuscule." In time, this style became the model for the small letters (minuscule) we use today. It is a text letter, and it spread quickly to other parts of Charlemagne's empire, where many new versions of the original added national or regional characteristics.

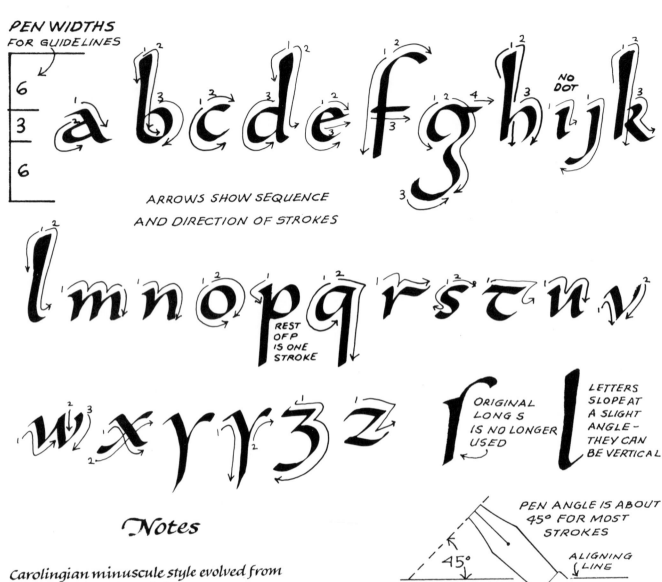

PEN WIDTHS
FOR GUIDELINES

6

3

6

a b c d e f g h i j k

ARROWS SHOW SEQUENCE
AND DIRECTION OF STROKES

NO DOT

l m n o p q r s t u v

REST
OF P
IS ONE
STROKE

w x y r z

ORIGINAL
LONG S
IS NO LONGER
USED

LETTERS
SLOPE AT
A SLIGHT
ANGLE —
THEY CAN
BE VERTICAL

PEN ANGLE IS ABOUT
45° FOR MOST
STROKES

45°

ALIGNING
LINE

Notes

Carolingian minuscule style evolved from
the roman half-uncial.

Punctuation marks were introduced during
this period.

The letters j and w did not exist at this
time and those seen here are later versions
or additions.

Roman old style and uncial were used most
often as capitals with Carolingian text.

The curved Carolingian letters became
pointed, compressed, and stiff to save space
and parchment, and led eventually to the
development of the compressed Gothic
black-letter style.

34

Dal
primo adunqᵻ
Tratto piano ᴇ͛gros:
so cioe' - - - che' alla riuersa
& tornando per il medeʃmo ʃe' incom:
mincia,
principiarai tutte' le'infraʃcritte'littere'
-abcdfghklogsʃx

Italic

In the fifteenth century, a slanted version of humanist writing was devised. It was called "italic" after Italy. The papal chancery in Rome used it and the early forms are called "chancery cursive." Around 1522, a prominent printer-calligrapher, Arrighi, published a copybook, "L'Operina," which gave detailed information on how to write italic. Other calligrapher-printers (Tagliente, Palatino, and Cresci) also made contributions to advance its broad acceptance. "L'Operina" displayed letters that were printed from woodcuts and lacked the look of freely written calligraphy. The book, however, became the model for writing italic and is still used today by many.

5

5

5

Height of the body
of small letters is five
pen widths. Ascend-
ers and descenders
are the same.

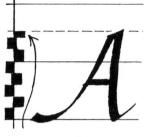

Height of capitals
is seven and one-
half pen widths.

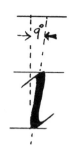

9°

The slant of
all letters is
9° from a
vertical.

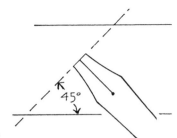

45°

The flat edge of
the pen is held
at a 45° angle.

The body of most of the small letters fits within
a parallelogram that has a width about two-
thirds of its height. These letters are a, b, d, g, h,
k, n, o, p, q, u, v, x, y, and z, and the c, e, r, s,
and t are slightly narrower.

The widths of m and w are more than their
heights, and the i, j, l, and f are the narrowest
of all.

ABCDEEFGHIJKL
MNOPPQQRSTU
VWXYZ &LLBEO
WThLGP

A sample of swash capitals
that can be used with the
small letters. There are many
variations.

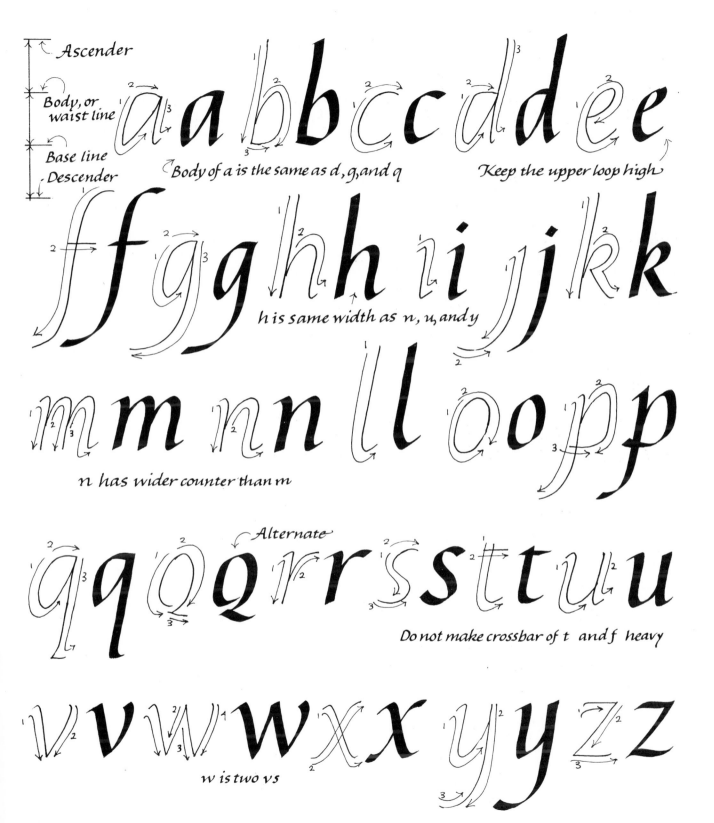

Ascender

Body, or
waist line

Base line
Descender

Body of a is the same as d, g, and q

Keep the upper loop high

aa bb cc dd ee

ff gg hh ii jj kk

h is same width as n, u, and y

mm nn ll oo pp

n has wider counter than m

Alternate

qq Qq rr ss tt uu

Do not make crossbar of t and f heavy

vv ww xx yy zz

w is two vs

Errors most often made by beginners

tttragkespvimor

1 2 3 4 5 6 7 8 9 10 11 12 13 14 15

From left to right: 1. the crossbar of t is never written above the waistline (it should touch the waistline underneath), 2. there should be more of the crossbar to the right of the down stroke, 3. the crossbar is too heavy (turn the pen slightly to make it thinner), 4. the terminal at the bottom should be larger, 5. the letter is too wide and too round, 6. do not flourish terminal strokes (NO WAVING FLAGS), 7. the bowl is too large, 8. the loop at the top is too large, 9. the void at the top should be smaller than the bottom void, 10. the hooked serif at top of first stroke should extend up slightly above the waistline, 11. the second stroke of v should not be above the waistline, 12. the i is double-curved instead of straight, 13. the inside counters should be the same size, 14. the o is too round and circular – it should be a flat oval, 15. the ear at top is too long.

the quick

All letters must slant in the same direction.

brown fox

All areas of space between adjacent letters should be equal.

JUMPS OVER THE LAZY

Words composed entirely of swash capitals are seldom used.

The Lazy Dogs

It is much more effective if swashes are kept to a minimum.

The tops of these letters → are formal italic. Do not mix them with informal b, d, h, k and l (previous pages).

bdhkl

38

Et ait angelus ei · Ne timeas maria: sueuisti ei gratiã apud

Black Letter

The Carolingian minuscule changed characteristics in the years following its inception at Tours. In some areas of the empire the text letters became more condensed, were written more quickly, and the appearance on a page had an overall look of black. Consequently, a new style, black letter, was recognized around 1200. In Germany it became a particularly heavy letter with short ascenders and descenders. Very decorative capitals were designed to go with the minuscules. The letters were spaced tightly. Condensing and the tight spacing allowed more letters on a page, which saved costly vellum. Except in Germany, the black letter died out and other styles took its place, due more to Renaissance thinking than anything else. The term "Gothic" is sometimes used to describe this style because it reflected the spirit of the Gothic architecture of the times.

in die Wüste eine Tagereise, und kam hinein, und setzte sich unter ei

R. Koch's woodcut black letters, 1920.

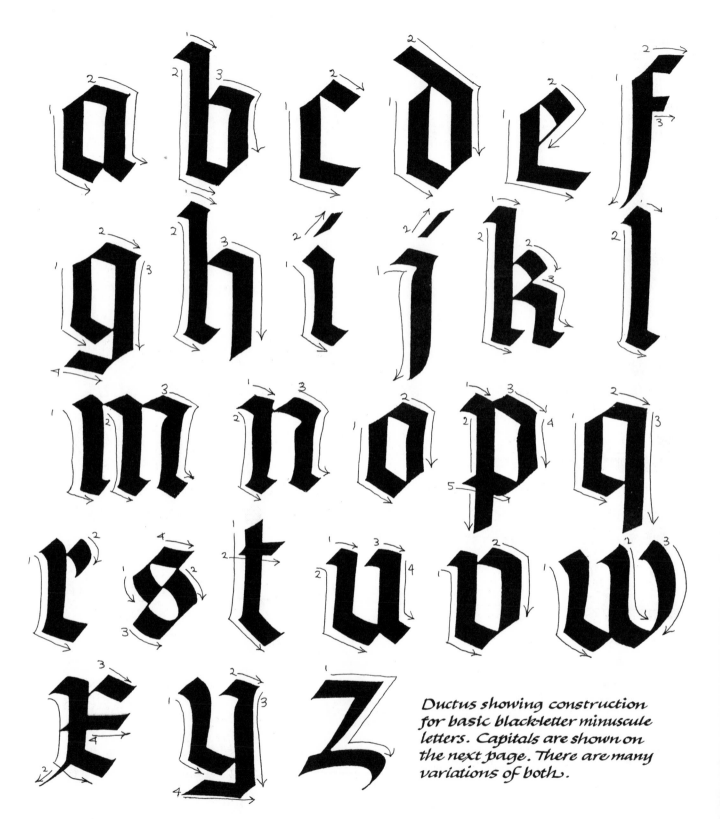

Ductus showing construction for basic black-letter minuscule letters. Capitals are shown on the next page. There are many variations of both.

aaabbccdef
gghiikklop
rsttuvwyz

The pen angle for writing black
letter is 45 degrees.

gothic textura Batarde
rotunda Schwabacher
Fraktur

Try to write the letters in the
fewest strokes.

Variations of black-letter
stylings are shown above.

A word entirely written in black-
letter capitals is seldom done.

When the letters are formed,
many of the strokes barely touch.

42

abcdefghijklmn

ABCDEFGHIKMQ

JWRSTLDWXYL

opqrstuvwxyz

But today the term "Gothic"
is a little confusing because
there are many monoline
typefaces called "Gothic"
that look nothing like the
written black letter.

The alphabets at the top and bottom of this page are from seventeenth-century manuscripts.

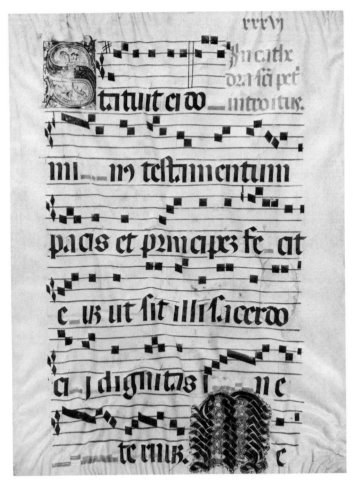

Music sheet inscribed on vellum, circa 1490.

Rotunda

Rotunda is a southern branch of the northern black letter, developed around the fourteenth to fifteenth century in Italy. The Italians did not care for the condensed northern version, preferring a rounder and wider letterform. It retained the packed spacing, had less line spacing in text than the northern version, and had many thin hairlines. Rotunda influenced greatly the later development of another style — humanistic script.

oyſes naſcitur)ſed n eſtatur. Credidit eni

greꝫcorum cómentariis ſunt relicta artis
certisq; rationis legibus emendaſſe: no
illos imitatorem eorum extitiſſe. quipp
ſtudiis litterarum ‚ppter inopiam ſcript

abcdefghijklm nopqrstuvwxyz

Cloister– a contempory type adapted from Jenson's.

Humanist Bookhand

In the early Italian Renais-
sance, humanistic writing was
developed. It had its roots in
the Carolingian minuscule
for the minuscule and in
the much earlier classic
roman for the capitals.
Some artists experimented
with geometrically drawn
capitals of old roman
lapidary letters. The small
letters took on an appearance
much like the roman
lowercase letters we use today
in type. In Florence and
Venice, during the fourteenth
and fifteenth centuries, the
written forms became the
models for humanists'
roman (upright) minuscule
and for the italic (slanted
version) of some of our first
typefaces. However, in
Germany, the black letter
continued to be popular.

45

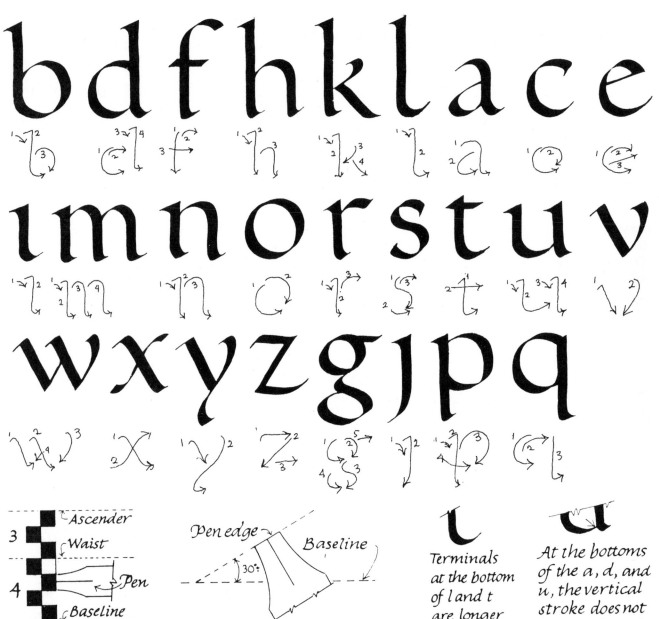

Diagram above shows how pen is used to establish guidelines for writing bookhand.

Pen angle is approximately 30 degrees.

Heads of many letters are written in two strokes.

Terminals at the bottom of l and t are longer than other terminals.

At the bottoms of the a, d, and u, the vertical stroke does not turn to the right until it meets the curve (arrow).

Turn pen angle slightly when writing crossbars on the t and f and the ear on the g so that they are not as thick as the vertical strokes.

Humanist Bookhand Capitals

A B C D E

F G H I J K

L M N O P

Q R S T U

V W X Y Z

Friendship is a strong and habitual Inclination in two Persons to promote the Good and Happiness of one another.

Written by J. Champion, engraved by G. Bickham, from "The Universal Penman", 1733.

Copperplate

In the late seventeenth and early eighteenth centuries, there was a need for a legible, quickly written writing style. This need was caused by the rapidly expanding industrial growth in England, which required much business communication. The typewriter was a later invention that served this purpose. English writing masters wrote copybooks of a running cursive style, which was called "copperplate," because it was inscribed on copper plates for printing model copy sheets. Some claim that this style is not a true calligraphic style; but that must be disputed, because it certainly is beautiful writing, and that is what calligraphy is. It is included here as the last major calligraphic style to be demonstrated.

George Bickham (circa 1700 to 1769) was an outstanding engraver-calligrapher, and his copybook, "The Universal Penman," displayed exquisite samples of copperplate by outstanding contemporary writing masters.

Copperplate is sometimes called "English round hand," "Spencerian," "formal script," "engraver's script," and "engrosser's script."

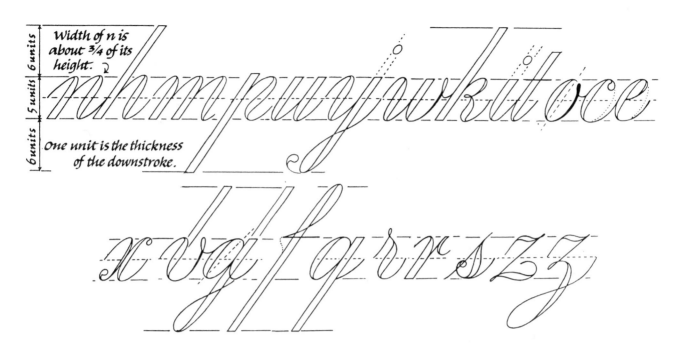

Width of n is about ¾ of its height.

5 units | 6 units | 6 units

One unit is the thickness of the downstroke.

The lettering above is an alphabet of copperplate script as a lettering artist might design it. It is used in an exercise for the beginner to learn the basic construction of copperplate before writing it directly with a pointed spring pen.

Draw guidelines on tracing paper to match those above. Lay this over the alphabet and sketch the heavy parts (down strokes) only. Then sketch the thin strokes as in the example below.

49

roses are red viole

The last step in the exercise is to draw guide lines on a new sheet of tracing paper and form words by moving the sheet back and forth over the alphabet as in the example above.

Common errors

ein out

1. The loop is too low.
2. Dot over the i is an oval, not a circle.
3. Too gradual a change from thick to thin.
4. Hairline joiner should be tight, not loose as shown here.

5. Hairlines should all be the same thickness.
6. Round joining element is too large.
7. Oval should slant less than 54°.

Capitals are written in the same manner as the small letters. An excellent model for you to follow is the typeface, Bank Script, shown below. Make variations of it, if you wish.

A B C D E F G H I J K L M

N O P Q R S T U V W X Y Z

fghijklm

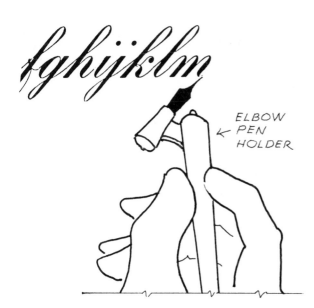

ELBOW
PEN
HOLDER

loiny

These six strokes occur most frequently. Study them carefully. Practice writing them with a spring pen and thin writing ink.

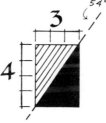

54°

3

4

You can cut a small cardboard triangle as in the diagram to use against a T-square and get a 54° angle.

Copperplate is written with a flexible pen. The heavy parts are made with pressure of the pen; these quickly turn into

extremely thin hairlines in forming or joining the letters through the exertion of less pressure from the pen. The capitals are formed in a similar manner, but usually include extra flourishing. They are written at a severe slant of 54 degrees from a horizontal.

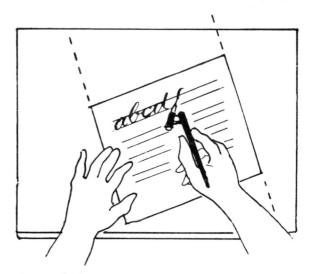

It will help you to maintain the 54° letter angle if you position the writing paper on an angle as shown above.

Written Sans-serif Alphabet

The alphabets shown here should be written with the Hunt's B-series Speedball pens or similar pens that have circular nibs, not pointed or chisel-edged. The lightly lined boxes around the capitals and numbers show the relationship of the widths of characters to the height. The numbers and arrows show the sequence and direction of the strokes.

This is a monoline alphabet.

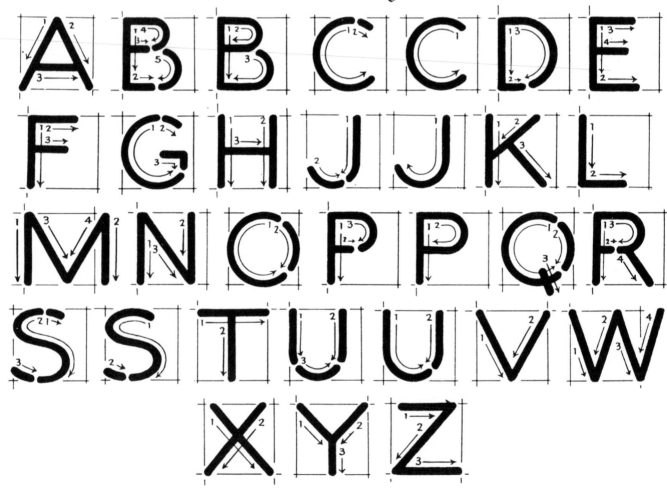

The height of the body of the
small letters is about two-
thirds of the height of the capitals.

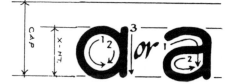

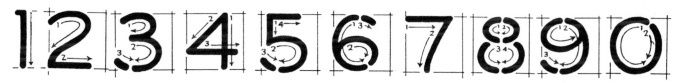

The numbers, with the
exception of number 1, are all
approximately the same width.

1234567890

Try variations of the style
shown by condensing and
extending letters. Try slanted
letters. The sequence of strokes
remains the same for all
versions.

This alphabet can be used
for quick signs and, if written
very small, can be used for
short notes or other
calligraphic works.

Type

After type came on the scene in around 1450, written letters were used less and less.

The first type, designed by Gutenberg for his 42-line Bible, circa 1450.

Almost all of the typeface stylings at this time tried to duplicate the handwriting of the current manuscripts. Soon letter styles developed typographically, instead of calligraphically, and traditional writing styles were used less and less.

Today there are many typeface styles that have a written look and can be used for inspiration for all calligraphers. Notable among them are the types of Hermann Zapf, Rudolf Koch, Warren Chappell, Victor Hammer, and others.

The humanistic style was exploited by printers like Nicolas Jenson, a French printer in Venice, who designed

oyſes naſcitur)ſed n eſtatur. Credidit eni
Jenson's old-style type, 1470

the beautiful old-style roman type used for the text of "Eusebius," a masterpiece of old-style roman letterform, in type.

O ſtendatur, ames nomen, uic
Manutius' italic, 1500

An italic type was designed by Aldus Manutius for writings of Virgil – another masterpiece of typography.

In the late nineteenth century, William Morris and Edward Johnston revived calligraphy in the English Arts and Crafts movement. Johnston wrote a book, "Writing and Illuminating and Lettering," which is considered by many to be the bible of calligraphy.

abc ABCDEFGHIJKLMN
OPQRSTUVWXYZxyz
abcdefghijklmnopqrstuvwxyz 1234567890

Ondine

abcdefghijklmn
opqrstuvwxyz

Lydian Italic

ABCDEFGHIJKLM
NOPQRSTUVWXYZ&
abcdefghijklmnopqrstuvwxyz1234.,!?

Commercial Script

Try writing the type styles, except the script above, with flat-edged pens.

ABCDEFGHIJKLM
NOPQRSTUVWXYZ

abcdefghijklmnopqrstuvwxyz

Lady—
an excellent model for writing free script.

ABCDEFGHIJKLMN
OPQRSTUVWXYZ
abcdefghijklmnoprstuwy

Freehand

**ABCDEFGHIJKLM
NOPQRSTUVWXYZ**

Neuland
requires double strokes and much pen manipulation.

Shown below are some contemporary typefaces
with obvious calligraphic characteristics.

abcdefghhijklmn
opqrstuvwxyz

Legend

abcdefghijklmn
opqrstuvwxyz

Zapf Chancery Italic

abcdefghijklmn
opqrstuvwxyz

American Uncial

Spacing

In calligraphy, the space between letters of a word, the space between words in a line, and the space between lines in continuous text are almost as important as the actual forming of the letters. Good spacing is really a visual measurement. The spaces between all letters in a word must appear to be the same size. The examples shown here are presented to help you develop a proper "feel" for good spacing. You will eventually acquire a good sense of spacing, if you are constantly aware of these concepts.

With capitals, letterspace is the area of white defined by the edges of adjacent letters and the top and bottom guidelines. With minuscule letters, the same is true, except the guidelines, top and bottom, are the body and baselines.

The space between two adjacent verticals in a word determines a unit for space evaluation, 1. A vertical next to a curve, 2, moves closer than 1, and two adjacent curves, 3, move still closer. The space between any two adjacent letters in all words of continuous text should appear to be the same.

The space between words should be the same throughout the entire text.

The space between two lines of capitals. It can vary from what is shown here but should not be more than the height of the capitals.

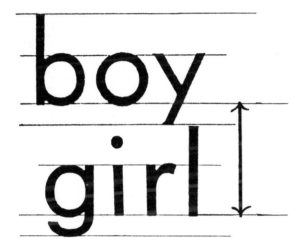

ASCENDER

BODY OR WAIST

BASE LINE

DESCENDER

boy

boy

girl

The spaces between lines of small letters is determined by measuring equal distances from baseline to baseline of the consecutive lines of text. In the sample above the descender line of the top line and ascender line of the bottom line are the same.

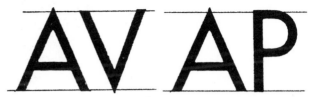

Some other letter combinations

AV **AP**

Diagonal next to diagonal
Same as 1.

Diagonal next to vertical
Same as 1.

WO **LT**

Diagonal next to curve
Same as 2.

Some combinations
can overlap.

VW **LA**

With some combinations all you can do is get the letters as close as possible without touching.

CEFGKLSTXYZ

Open sides of these letters should be close to adjacent letters.

Spacing concepts expressed on these pages apply to all calligraphic styles.

This page shows the
overall effect every
calligrapher should
try to get when
writing paragraphs
of continuous text.

Above is a greatly enlarged printed
halftone of continuous tone. The distance
between the dots, and the size of them,
varies to give an illusion of varying tone
as in a black-and-white photograph.
This is NOT the effect you want when
writing many lines of text.

raphic writing (done with a
to a running, joining, and
anted style (done with a flexi
ointed pen). Master engraver
alligraphers produced copysk
nd copybooks to be used as mo
ngraving tools and the pointec
ntributed to the character of
tters more than anything else
yle had a great influence on
odoni typeface, a modern Ro
ule designed around 1780 b.

To the left is a screen tint with the dots
equally spaced throughout to give the
visual effect of a flat, even tone of gray.
This is the overall effect you should try to
get when writing large areas of text, as
in the writing under it.

Notes on spacing letters

HEAVY ON
HEAVY ON

The word on top "reads" HEAW. In situations like this, leave a little space between letters (below).

WAVE

Two light diagonal strokes next to each other will be closer than two heavy diagonals in the same word.

NIB

A vertical hairline next to a vertical stem should be closer than two vertical stems.

G E

When letters with open sides are written like the above (almost enclosed) they can, for spacing purposes, be considered to be the same as O and H.

staff

Space between two letters of a ligature, such as ff, should be the same as other spaces in the word.

AND MORE

Packing letterspacing is a fanciful contempory fashion.

Hold work to a mirror to evaluate your spacing.

In continuous text, the letterspacing should be the same throughout.

aaaaaaaaaaaaaaaaaaaaaaa

aada gaadea dad aeae agd

As you learn a new calligraphy
style, instead of writing
countless lines of individual
letters, make up meaningless
words and practice spacing
them as well, as in the
example above.

the quick

the quick

When you see a mistake in
spacing after you have finished
finished writing a piece of
calligraphy, you might correct
it visually by joining the letters.

Word Spacing

Word space is the space between words in a line of writing. Before A.D. 600 most writing had no word spacing; but in some writings a dot, small triangle, or other device was inserted between words.

saving over first class when individual pieces to be mailed weigh over an ounce. A greater saving is realized with third class bulk rate which is based on cents per pound. The use of this rate requires a permit — a Third Class Bulk permit — and the mailing list to be used must be completely zip-coded. All mailings using this rate must satisfy postal regulations, two important ones being preparation or design to allow postal inspection and a legible designation "Third

ward to a mutually rewarding experience for ourselves, as well as our adult students. If you would like to be contacted by one of these alumni, please check box

of tracing paper. With a flat-edge tool held at an angle of 15° to 20°, develop your Roman capitals by moving the tracing paper over the diagram (B). Remember your letter proportions (which are half as wide as high, which are three-fourths, which are circular). Two typical letters are sketched for reference (C). Don't fret if your letters are not exactly proportional — it's not that important. Develop your word by moving the tracing paper

All word spacing should be the same throughout continuous text, except where a right-hand margin for the text is to be flush. In that case the word spacing changes to accomplish this alignment. Letter spacing, however, never changes for this purpose.

Type is used here to demonstrate how words are spaced in a paragraph to align the right-hand margin. Note the difference in the word spaces on each line; some are small and others are generous. This kind of spacing is seldom done in calligraphy but, when it is, a few preliminary sketches of the copy must be written until a right-hand margin is aligned. When this is accomplished, proceed to the finished work.

The unit for spacing words is the width of an N or O.

*Suppose you have a circle
and want to organize the
writing as shown below.*

The quick brown fox jumps over the lazy dog

First, arbitrarily write the copy rather carefully on a straight line. Divide this line into quarters and mark it accordingly. Then divide the circle into quadrants, as shown. Now lay tracing paper over it and write carefully, only putting as much copy in a quadrant as you have on the

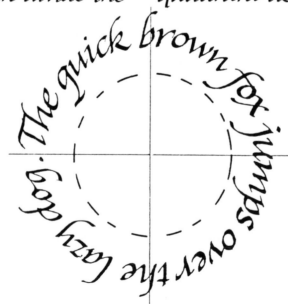

line, which is divided into fourths. The writing should fit around the circle. Overlay finishing paper over the circle and write your final calligraphy. If you want to include a symbol or logotype in that copy, allow for this in the original line before dividing it into quarters.

If you want more precise fitting, as in a large wall sign, divide into eighths instead of quarters.

When you write around a circle, ellipse, square, or any regular shape, the method shown will help you organize the copy so that it fits.

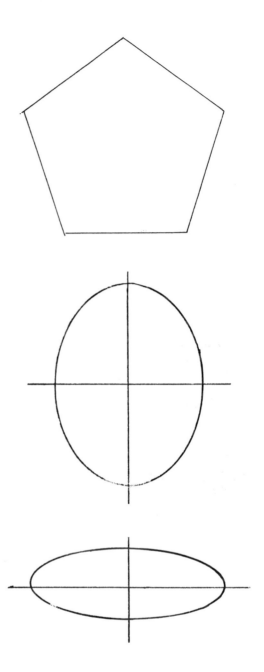

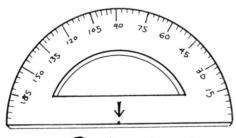

Use a **Protractor** for measuring angles.

For ellipses of any size or regular shapes like the pentagon (top), proceed in the same manner.

Line Spacing

When spacing lines of capital letters only , the space between lines should be less than the height of the capitals.

THE QUICK BROWN FOX

loving thoughts
And thanks ⌐SPACE

ↄ With minuscule letters, be careful to design your lines of text so that the descenders of one line do not interfere with the ascenders of the next line underneath.

Mother,
this brings
our loving thoughts
And thanks
and wishes, too

Mother,
this brings
our loving thoughts
And thanks
and wishes, too

If your work is to be for reproduction, simply write your lines and, when finished, spray lightly with fixative and cut them apart. Paste the lines down on another sheet, centering as you progress. Light blue pencil guidelines can remain on the finish, because they will not show when photographed for reproduction.

Mother
this brings
our loving thoughts
And thanks
and wishes, too

Because it means
so much to us
To have a Mother
like you

Mother,
this brings
our loving thoughts
And thanks
and wishes, too

Because it means
so much to us
To have a Mother
like you

Centering lines of calligraphy requires a little bit of simple planning. One method is to first write the lines in pencil or ink rather carefully. Find and mark the center of each line. On another sheet draw a center line on the back side, turn it around, match it with the center mark of the lines, and write the finished piece. Be careful to line-space the lines equally and make them parallel to each other. When finished, erase the center line from the back side of the finished piece.

Space between verses of a poem should be the same as one line of the verse.

Shown here are the most common
ways to organize many lines of
calligraphy, as in a paragraph.

A

Flush left, ragged right.

B

Flush right, ragged left.

C

Flush left and right.

The word spacing in each line is
different from the spacing in other
lines in order to get a vertical
alignment of the right-hand
margin. The letter spacing in
all lines should be the same.

D

Centered lines.

Make your own line-centering device.

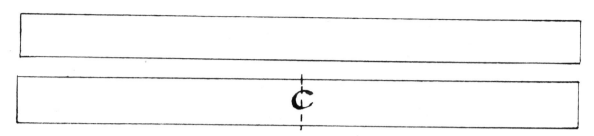

Cut a strip of thin card to 18
inches by 2 inches (approximate)
and fold it in half. Mark the
center with a large C.

On the edge of a small piece
of paper, make two marks
about ½ inch apart.

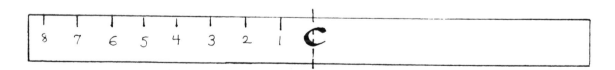

Starting at the center and
moving to the left, mark
continuous divisions on the
edge of the card. Number
them as shown.

Repeat the same procedure
but move to the right of center
this time and number the
divisions as shown. When
completed, you have a device
for finding centers of lines
of writing.

Move the device back and
forth over a line of writing
and match numbers with the
ends of the line. Mark the
center on the line.

Repeat this same procedure
on other lines, and match
the centers with a common
center line on your finished
writing.

Use a light box if you have
one.

Pens

The primary tool for writing calligraphy is the flat-edged pen. The Egyptians used a pen cut and shaped from the hollow reeds that grew in marshes along the Nile River. Quill pens, made from bird feathers, were cut and shaped in the early Middle Ages. Much later, around 1800, flat-edged metal pens were manufactured in England, as were flexible pointed ones for copperplate writing.

Pen tips

When pens are first bought, they have a thin protective oil covering them. Remove this with saliva and tissue, or dip it in ink a few times and immediately wipe it clean. Never pass it through a flame; doing so may separate the parts of the pen and ruin it.

Shown below are some of the pens used by calligraphers. They are all made in many sizes.

Hunt's Speedball C series. Similar other pens are Brause and Mitchell.

Coit pen

Pointed spring pen

Technical pen

Felt, or nylon, chisel-pointed Marker pen

Try all kinds of pens and find the ones with which you prefer to write. Also, try different papers and surfaces.

———————

Pens should be cleaned immediately after use. Never put a pen down without first cleaning it.

———————

Be sure to keep caps on fountain pens, technical pens, and such when not in use. They may dry and clog if you do not.

———————

Use pliers and move the entire nib end of a technical pen back and forth. Do this after immersing the entire end in warm water.

———————

Never apply pressure to a flat-edged pen to get a bolder stroke; let it glide over the surface.

Never use hot water to clean pens (or brushes).

———————

When learning a new style, use larger pens at first, gradually using smaller ones for smaller letters.

———————

Write over alphabet models with a dry pen to get the "feel" of the letters, using the correct pen angle.

———————

Store pens with the nib up. This is particularly true of fountain and technical pens.

———————

Wash pens with cool or warm water and household ammonia.

———————

Never let someone else borrow your pens.

When you clean a flat-edged pen, such as the Hunt's C-series Speedball, first tap the excess ink back into the ink bottle after using. Immerse the pen nib in the water jar and then tap it into the wastebasket. Immerse the pen into your ammonia bottle and tap it into the wastebasket. Then take a small piece of blotter, insert it into the

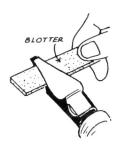

reservoir, and move it towards the pen nib. Use a corner of the blotter to clean around the underneath part of the pen, as shown.

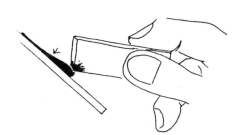

Finally, insert a small piece of bond or other thin paper under the flange on the underpart of the pen as is shown in A. Be careful not to separate this flange from the pen, for it should always be in contact with the pen. Move the paper back and

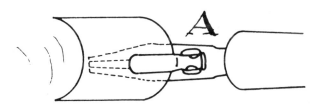

forth to clean the ink out. Dry the pen by wiping it on a rag, and store it away with the nib up.

A little glass cleaner or other household detergent can be used with water to flush out and clean fountain pens or technical pens. A little in your water jar will help the ink flow.

Cotton and linen are the best cloths to use as wipe rags because the fibers are less likely to clog the pen.

If you make your own bamboo stick or feather pen, soak well (a few hours) before cutting and shaping.

Gillott 303 or Hunt 101 are the most often used pointed spring pens for writing copperplate.

If your metal pen gets damaged, throw it away. You will waste time trying to repair it.

Show the size and maker of pens on a small piece of white tape and wrap it around the handle.

There are special flat-edge pens made for left-handers (check with your dealer).

Swan quills are considered best for quill pens.

Coit pens are made of brass with plastic handles. They can be left in water indefinitely without rusting or corroding. An old brush can be used to clean out the slots. If you use them frequently, store them in water. They are made in many sizes.

The inside of a tape roll can be used for a pen rest. Cut notches.

Wrap a rubber band around the end of a pen to prevent it from slipping into ink, etc.

Use Kleenex and ammonia to clean inks from your hands.

A toothbrush and household ammonia are handy tools for cleaning ink from pens.

Use unwaxed dental floss, string, or thread for cleaning the openings in a Coit pen.

Try household window cleaner to clean metal nibs.

Do not use lacquer thinner to remove water soluble ink from your hands; it will cause skin problems.

If you use hand lotion, for dry skin, be sure to wipe your hands clean before writing calligraphy. Your pen may skip over the paper if you do not.

Lava bar soap purchased from your local grocery store is effective in removing some inks from your hands.

If the sticky stuff from adhesive or white tape remains on surfaces and is difficult to remove, rubber-cement thinner will help take it off.

75

Ink

Most of the ink used for calligraphy is water soluble and is made from carbon, charcoal, ox-gall, lamp black or dyes. Waterproof ink is much the same but has varnish or shellac additives to make it waterproof when dry. Some calligraphers make their own ink by rubbing a stick of compressed carbon (sumi) on a plate with a little distilled water and gum arabic added.

Tips on ink

The most common inks used today are the Pelikan Fount India, Higgins Eternal Black, Hunt's Speedball, F&W, and tube lamp black or ivory black, which is thinned with water. There are others and you will have to find the one you like best. I highly recommend the Pelikan Fount India Ink.

Never mix waterproof ink with water-soluble ink.

———————

Never open ink bottles over artwork; little specks of carbon may fall on the work and are difficult to clean.

———————

Never add faucet water to ink for any reason. Use distilled water to prevent the ink (or tempera) from getting moldy and odiferous.

———————

Ink left in brushes is damaging; the ink dries in the heel of the brush and may ruin it if not cleaned with soap and warm water immediately after use.

———————

Tube lamp black has finer ground carbon than most inks and, if used as ink, will lessen the problem of ink flow from the pen.

Sumi ink in the bottle is the finest ground ink made.

A <u>little</u> alcohol mixed with ink may cause the ink to flow more quickly. A little vinegar mixed with ink slows the flow.

A little gum arabic added to watercolor or ink will give a slight gloss and will slightly retard ink drying on the pen.

Gum sandarac resin can be dusted over your writing surface, and fine ink lines are then possible. It will also help prevent fuzzy hairlines if dusted onto absorbent paper. (Some people may have an allergic reaction to gum sandarac. You can use powdered pumice instead).

When opening a bottle of ink, hold the bottle on the drawing board with the left hand and twist off the top with your right hand.

If you have trouble opening a jar of paint or ink bottle, twist the top back and forth. Dip the closed bottle in warm water first for difficult tops. If it is impossible to remove the top of poster color, break the glass, pick the color out, and put in another clean jar, adding distilled water and a drop of gum arabic. Tube paint can be saved in the same manner.

If ink is too thin, or weak, leave the top of the bottle off for a few days to thicken the ink.

If ink spreads on paper, spray the paper first before writing with a light coating of workable fixative.

———

Humidity may cause your lines to bleed on the writing surface. Be sure your paper is dry before using it.

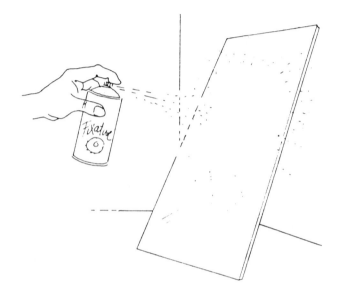

If you must write on oily, waxy, shiny, or glossy surfaces, spray the writing area first with a few light applications of workable fixative, or dust your paper with powdered pumice (pounce).

For drawing guidelines, etc., make your own non-repro ink (ink that will not reproduce when the printer photographs your black-and-white calligraphy for reproduction) by mixing waterproof turquoise ink with a little distilled water.

———

———

If you must retouch water-soluble ink on calligraphy, spray first with workable fixative and then use white paint for retouching.

To prevent your ink bottle from tilting over, cut a hole in a flat sponge and use as a holder for the bottle.

Watercolors thinned down with distilled water and mixed with a drop of gum arabic make good colored "inks."

———————

Never put waterproof ink in fountain pens. Read labels and follow the manufacturer's instructions.

———————

Wipe the cover and the opened top of bottle occasionally with a tissue to avoid ink buildup.

———————

If you first outline letters in ink, to be filled in later, use a denser ink for filling in.

———————

Save old ink bottles. Clean them and use them for holding household ammonia (an excellent cleaning agent). You will find the bottles have other uses as well.

Throw away any ink that is over a year old.

———————

Gently shake a bottle of ink every time you use it, because the carbon settles to the bottom. Be sure the top is secure when you shake it.

———————

Occasionally wipe the top (screw part) of your opened ink bottle with tissue (also the inside of the top). It will be easier to unscrew it next time, and you will minimize the possibility of specks of carbon from the ink getting on your work. They are very difficult to remove if smudged over artwork.

———————

There are gold, silver, and white inks made for the calligrapher. Talk to your supplier for information about them.

Subtle effects can be achieved by writing with wine (burgundy) instead of ink.

———————

Try writing with liquid bleach instead of ink on colored papers or blotters for interesting effects.

———————

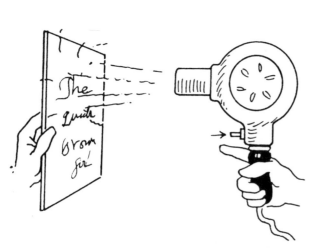

A hair dryer is handy for drying calligraphy.

An ear syringe or tip of blotter can be used to remove pools of ink from calligraphy. You will not have to wait so long for it to dry.

———————

Radiators and desk lamps can be used to dry wet calligraphy.

———————

If you have a desk lamp with a flexible arm, bring the shade close to your writing or turn the shade around, put a small screen over it and lay your calligraphy on it.

———————

If you travel by plane, empty your fountain pens or pack them in a waterproof container; the sudden changes of cabin pressure may cause ink to leak.

Paper

Thousands of years ago, the Egyptians used a writing surface that was made from long-stemmed papyrus plants. The stems were cut and mashed together in a criss-cross pattern and formed into rolls of papyrus to write on. The word "paper" comes from "papyrus." The early Greeks and Romans used papyrus to write on until later, when they used animal skins that were stretched and prepared for writing. If the skins were from oxen, sheep, and goats, they were called "parchment," and if from calf or lamb skin, "vellum." Most desirable of all was the vellum made from unborn lamb. In A.D. 105 in China, Ts'ai Lun produced a substance made from vegetable (cellulose) fibers, which was true paper. At around A.D. 1100, paper was introduced into Europe; the first mill was Fabriano in Italy (1283).

There are over 7,000 kinds of paper made today, most of which are for printing. The suggestions below are just a few to help the beginner in selecting and using paper made for writing calligraphy.

Tips on paper

Blue-lined graph paper is great for practicing writing. Since the blue lines do not show in reproduction, the paper can also be useful for work to be reproduced.

———————

Hammermill Duplication Paper is excellent for both practice and reproduction. Buy it by the ream (500 sheets) in 8½-by 11-inch size.

You can save much money by using newspapers for practicing calligraphy with brush or marker pens. Turn the paper on its side and use the column lines as guide lines.

Do not use tissue paper for calligraphy; it is made for wrapping presents or blowing your nose in.

Save junk mail that might be used for practicing writing.

Plastic vellum is an excellent surface to write on for work that will be reproduced. It comes in sheets that are 11 by 17 inches and expensive.

You can write to paper manufacturers (see page 120) for samples. Try samples using different pens and inks.

Basis weight of paper is the weight, in pounds, of a ream (500 sheets) in a certain basic size.

M-weight is the same for 1000 sheets.

If you find brownish edges on white paper or illustration board due to old age, clean them by gently rubbing with clean rags and household bleach (Clorox).

Dampen the end of a finger by touching it to your tongue to remove little pieces of paper from your writing surface, as shown above.

If you can read the watermark on a sheet of paper, that is the side on which you should write. Some papers have an embossed corner stamp near one of the corners of the sheet.

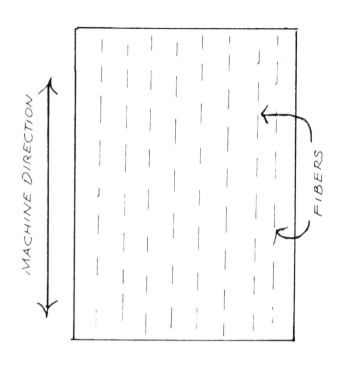

MACHINE DIRECTION

FIBERS

"Try writing on every kind of material you can think of."

———

Cards or paper on which copperplate is written should have a smooth surface.

———

Any sheet of manufactured paper has a grain - that is, the position of the fibers that are parallel to one side of the sheet. This grain is called the machine-direction. The other dimension is called the cross-direction. Paper folds smoothly <u>with</u> the grain. A fold is rough, or cracked, when folded cross-grain. These factors must be considered when making a design with folds, as in a booklet, when the grain should fold in the same direction as the binding edge of the booklet. ——→

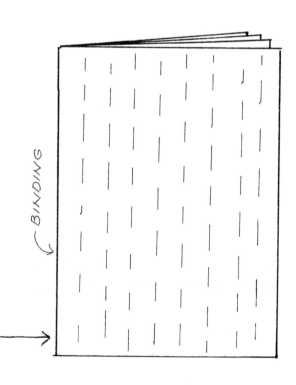

BINDING

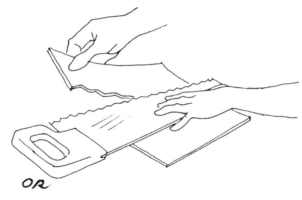

A deckle edge on a sheet of paper looks like it is torn. Actually, it is the unfinished, or untrimmed edge of the paper when it is made. A method of getting this effect is to lay a straight edge (ruler) near the edge of paper and tear it manually.

OR

Hold a saw firmly against the edge and tear the paper, pulling against the saw.

OR

Burn, here and there, and clean up. This gives the deckle edge an antique look as well.

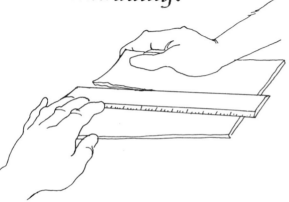

OR With scissors, cut back and forth along a line.

Pencils

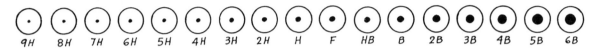

9H 8H 7H 6H 5H 4H 3H 2H H F HB B 2B 3B 4B 5B 6B

Most pencils are made from graphite. The different grades are shown above. 6B is large, soft lead and produces thick, black lines. 9H is a very hard graphite and produces thin, light lines. HB and F are good all-purpose pencils.

Choice of pencil depends mostly on personal preference and the kind of work you are doing. Besides graphite, other pencils are made from charcoal, grease, chalk, Conté crayon, etc.

Wood pencil, with or without eraser

Metal mechanical pencil

Stabilo pencil - for shiny, glossy surfaces

A pencil holder will allow you to use a pencil up to the last inch.

Two pencils tied together can be used for drawing guidelines. Put wedge between for larger distances.

Use chisel-shaped pencils (you can sharpen them) for practicing flat-pen lettering— it will save ink and paper.

The two tied pencils can be used to design scroll, and other, letters.

Glue a piece of sandpaper to one side of a tongue depressor to make your own lead pointer.

A "carpenter's pencil" can be sharpened like a chisel to practice large flat-edge writing.

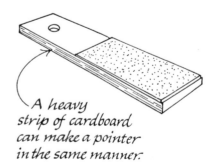

A heavy strip of cardboard can make a pointer in the same manner.

Markers

If marker ink is a water-soluble fluid it can be removed by washing with soap and warm water and a little lemon juice when you get it on your skin. If you spill it on your clothes or carpet, you might try one of the following methods for cleaning:

Marker pen tips are made of felt or nylon. The flat chisel-edge ones are good for practicing writing most calligraphy styles. They are made in many sizes and colors.

1. Sudsy household ammonia – use ½ cup with a bucket of warm water, or use directions on the bottle (use with adequate ventilation).

2. On carpet you might try rug shampoo, but it may not emulsify.

3. A mixture of cornstarch and water (not too thick) is sometimes effective – rub in, let dry and then vacuum or brush.

If they get dry they can be "refilled" by dipping the tip in marker ink for an hour or so.

Write to the company that makes your marker and get ink for refilling pens. Also ask for a cleaner if they have one.

If you carefully cut a notch in the tip, a scroll effect can be written.

The same result can be achieved by applying a thin strip of tape to the tip.

Copperplate script can be written by turning and twisting the flat-edged marker.

Brushes

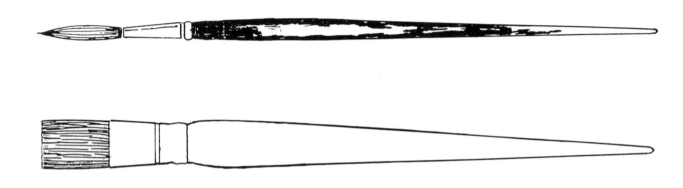

The two brushes used most often to write calligraphy are the flat edge and pointed watercolor brush. The flat-edge brush is made from animal hairs or nylon "hairs" and has a crimped ferrule. The watercolor brush is also made from animal hairs but has a rounded ferrule. Both are made in many sizes.

The flat-tipped brushes write all styles that are made with flat-edged pens. The watercolor brush is used to write script when held vertically, or the side of the tip can be used to make distinctive brush letters in the Maxim style which follows. The brushes can be manipulated to produce the writing below, where the side of the tip is used to form the letters.

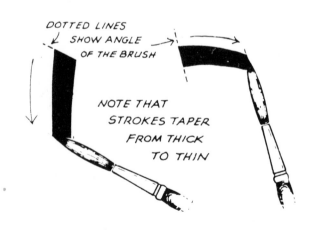

DOTTED LINES SHOW ANGLE OF THE BRUSH

NOTE THAT STROKES TAPER FROM THICK TO THIN

ABCDEFG
HIJJKLM
NOQQRST
UVWXYZ
abcdefghijkl
mnopqrstuvw
xyz1234567890

The alphabet shown here is a typeface, Maxim, designed by Peter Schneidler. It is an excellent model of brush lettering for you to practice, using the side of a pointed brush and watercolor.

Keep one brush for white retouching only. Never use it with any other color.

———

After using brushes, store them flat to dry, not upright on end in a container. If you do, water will get into the handle, causing the coating on the handle to crack, and paint residue will collect at the base of the brush.

———

An old, worn brush might be used for special effects (texturing, spattering, etc.). If not, throw it away.

———

If you have trouble with a spread card (on which you prepare paint for brush lettering), spray it first with fixative, and fibers will not lift up.

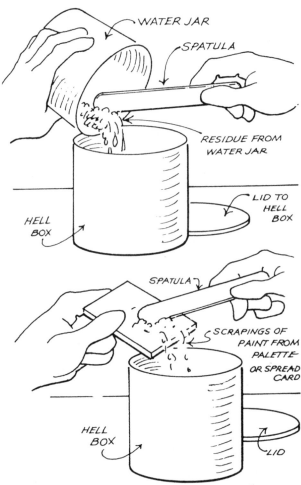

Scrape out the residue left at the bottom of your water jar into a clean container when changing water. Add the leftover watercolor paint scrapings from the spread cards, when you have finished brush lettering. Add a few drops of gum arabic. This new container is called a Hell box, and the new "color" can be used for many purposes.

Other Tools

In addition to pens, pencils, ink, brushes, and paper, there are other "tools" that will help the calligrapher. Some are shown on these pages.

UTILITY KNIFE

X-ACTO KNIFE

PATTERN WHEEL
(USE TO MAKE GUIDELINES)

Q-TIP

SWAB

TWEEZERS

EYE DROPPER

TALC POWDER

DUSTING POWDER

TALC

AMMONIA

AMMO

TAPE

COTTON BALLS

SCISSORS

MAGNIFYING GLASS

BOX OF TISSUE

RULED SHEETS

THESAURUS

DICTIONARY

TWO
BOOKS
YOU WILL USE

NEEDLE POINT

PEN NIB

SHARPENING
STONE

DRAWING
INSTRUMENTS

PAINT

TONGUE
DEPRESSOR

PROPORTIONAL
SCALE

PINK PEARL
ERASER

PLASTIC
ERASER

ERASERS

underliners

An underliner is a writing aid to place under your writing paper. It makes the drawing of guidelines on the paper unnecessary, saving time and annoying erasing. An underliner can be made from bond paper, thin illustration board, or acetate. The lines are drawn in black ink to make them more visible through the writing paper. If you use a light box, underliners are especially helpful. You can make one underliner for guidelines for writing, another on acetate to place over the writing paper to help keep the slant of letters consistent. Attach the pieces together with thin tape in any arrangement you wish.

UNDERLINER

SLANT SHEET (ANY SIZE)
ALL LINES ARE PARALLEL.

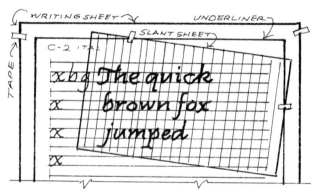

* Mark and file underliners if you make them for repeated use.

⟵ — A stencil for writing addresses on envelopes can also save much time. Simply measure your distances on a thin card and cut them out to use, as shown.

Numbers

Letters are symbols for sounds. Numbers are symbols for quantities. The Romans used capital letters I, X, C, and M for unit, ten, hundred and thousand, and V, L, and D for 5, 50, and 500, which were used to shorten long and difficult-to-read combinations. If a letter appeared in front of another, as in IV, the one was subtracted from the other (IV stands for four). If it appeared after, as in VI, it was added to the other (VI stands for six). This was true for all other numbers.

The numbers we use today came to us from western Arabia (and India), from about A.D. 1000, via Pope Sylvester II. It was not until 1200, however, that Europe adopted the system, which was not fully developed and absorbed until approximately 1500, when the ascenders and descenders were introduced. They remain today and are called "old-style" numbers.

During the nineteenth century, all numbers were designed to be the same height or to align with capitals. This style is referred to as "modern." Old-style numbers are harmonious with minuscule letters, while modern are more compatible with capitals.

1 2 3 4 5 6 7 8 9 0

Non-aligning old-style numbers

1 2 3 4 5 6 7 8 9 0

Aligning modern numbers

Notes on numbers

١ ٢ ٣ ٤ ٥ ٦ ٧ ٨ ٩ ·
East-Arabic numerals

1 2 3 ٤ 5 6 ٦ 8 9 ·
West-Arabic numerals

———————

אֱ 1 הַ 5 טִ,עִ 9
בּ 2 וַ 6 יִ 10
גּ 3 זַ 7 כּ 20
דּ 4 חַ 8 לַ 30

Today, some Hebrew religious writings use their alphabets as page numbers, as they did in ancient times.

1 1 1

The number 1 should have a half serif at the top to distinguish it from capital I and minuscule l.

———————

O O

The letter O is wider than the numeral O (zero).

———————

with 12345 men and 67890 horses

Use old-style numbers with minuscule letters.

WITH 12345 MEN AND 67890 HORSES

Use aligning modern numbers with capitals.

Glossary

The following are names of terms used in calligraphy. Many terms are explained in other parts of the book.

ampersand: a symbol that stands for "and" derived from the Latin "et."

Whimsical use of an ampersand for a T-shirt.

analogous: colors closely related to one another, such as blue, blue-green, and green.

asymmetrical: in design, elements that are not symmetrically or formally balanced.

abcdefghijklmnopqrstuvwxyz

backslant: writing that slants backward, the opposite of italic.

burnisher: a tool (wood, plastic, metal, ivory, etc.) used to flatten or polish a surface by rubbing.

character: one individual letter, number, or punctuation mark of an alphabet.

chisel-edge: a point of pencil shaped to have a flat edge like a chisel.

classic: any reference to an outstanding model; usually refers to early Greek and Roman cultures.

colophon: a statement at the end of a book telling about the style of letters used, process of printing, and other like information about the book. Also a trademark or device used to denote the publisher of a book.

comp (rehensive): a finished layout; next step is finished art.

cuneiform: the first writing of the Sumerians some 5500 plus years ago, done with wedge-shaped tools.

Your handwriting
cursive: joined writing.

deckle edge: uneven edge of paper caused by the process of paper making.

demotic: the ancient script "of the people" in Egypt.

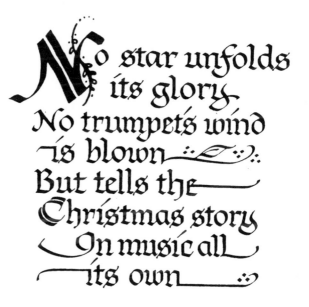

No star unfolds
its glory,
No trumpets wind
is blown
But tells the
Christmas story
On music all
its own

drop initial: first letter of a paragraph dropped to align with one of lower lines of copy.

Spring

drybrush: an effect produced by dragging a semi-wet brush lightly across a rough surface.

ductus : diagram showing sequence and direction of strokes in forming letters.

ellipse : a regular rounded shape ; not a circle or oval.

ellipsis : punctuation mark denoting an omission.

exemplar : a model, specimen, or example.

ferrule : metallic part of a brush that holds the hairs.

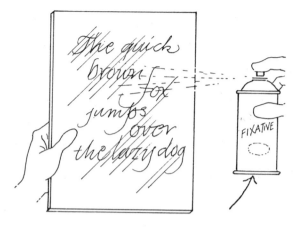

fixative : a protective coating sprayed over artwork.

folio : a sheet of paper folded once to give four pages. Also, the page number in a book.

gouache : French word for opaque watercolor. Tempera.

grain : direction of fibers in a sheet of paper.

gutter : blank space between two columns of writing.

head: the top of a page. (Foot is the bottom.)

illumination: hand decoration of book or manuscript.

impasto: thick application of paint.

1450 to 1500

incunabula: the first fifty years (approximately) of printing.

justification: aligning the margins of text flush left and flush right.

laid (paper): paper with parallel watermarks.

layout: a plan showing the organization of all copy to appear within the limits of a certain area.

leaf: single sheet of paper.

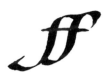

ligature: a combination of two or more letters into one unit.

logotype: a trademark or nameplate.

lowercase: a type term for small (minuscule) letters.

majuscule: large or capital letters (uppercase, in type).

manipulation: turning and twisting pen to form letters.

measure: the length of a line of writing.

metric : a system of measurement : 1 meter = 39.37 inches ; 1 centimeter = 2.54 inches ; 1 yard = 0.9144 meters ; 1 foot = 0.3045 meters.

minuscule : small letters (lowercase, in type).

monoline : a line of uniform weight.

morgue : a file of clippings, etc., used for reference.

negative space : space in and around letters.

opaque : paper or paint that does not permit light to pass through it.

oval : egg shaped, not an ellipse.

parchment : skins of oxen, sheep, and goat prepared for writing.

quill : a writing pen made from a bird feather.

ragged : unjustified text. Left and right margins are irregular.

recto : right-hand page of a book : opposite of verso (left).

reed : pen made from hollow marsh grass or bamboo.

Renaissance : a revival of classic art and culture from fourteenth to sixteenth centuries in Europe.

rhythm : repetition of similar elements.

roman: a style of letter; also means upright or vertical.

running head: the title of a book or section of a book, repeated at the top of all pages.

set: the width of a letter compared to its height.

ABCD efghi KLMN

small caps: capital letters whose height is equal to the x-height of minuscule letters of an alphabet.

spine: the bound edge of a book.

spread card: a small piece of card or illustration board on which paint is spread to prepare a brush for lettering.

subhead: a secondary title.

thumbnail: a rough, small idea sketch.

underliner: predrawn guidelines inserted under translucent paper for writing.

uppercase: a type term for large (majuscule) or capital letters.

vellum: skins of calf and lamb prepared for writing.

visualize: a mental image of a design prior to drawing a rough sketch. A rough sketch is a visual.

void: space inside of a letter.

wet-in-wet: a technique of getting blended color effects by adding ink or paint to a wet letter, image, or area.

The quick fox

x-height: the height of the body of minuscule letters.

Two versions of writing on a paper towel. The top line was written with a flat-edged brush and black poster paint. The bottom line was written with a wide flat-edged marker.

CRASH

This word was first lettered on a sheet of white bond paper. It was then crumpled and secured to a flat card and then photographed, and the print retouched.

"Weekend in New York"

This writing was done on a white blotter with pen and ink. To prevent the ink from spreading too much, spray a little workable fixative on the blotter before writing.

the quick brown fox

The words above and below were written on colored paper using _fresh_ household bleach (Clorox) as ink. When dry, they appeared as a beautiful tint of the color of the paper. They were retouched for reproduction here in black and white.

 Colored paper must be used. The bleach has no effect on color which has been _printed_.

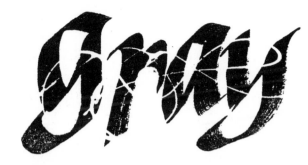

Rubber cement was first dripped from a loaded stick. When dry, a flat-edged marker pen was used for writing over the rubber cement line. When dry, the rubber cement was removed.

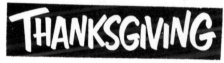

THANKSGIVING

sweeping curveball
sweeping curveball

The writing above was cut in two on a curved line and pasted down with space between the two parts as shown. The writing below was done in a similar way.

105

The letters were first done on
a white card with white
poster paint. Waterproof ink
was then quickly brushed over
the letters. When dry, the card
was washed under a spigot
in the sink and the lettering
appeared as shown. Other
poster and ink colors result
in the same effect.

This letter was written on
white bond paper with a
white wax crayon that had
the tip cut to a chisel edge.
Ink was then brushed over
it. Any color of crayon, ink,
or paper can be used to get
a similar effect.

Dr. Berthold Wolpe, a noted
graphic designer, says all
calligraphers should write
on every kind of material
they can think of, or find.

Selling Your Calligraphy

When you think the quality of your calligraphy is good enough to sell, you should contact (by mail, phone, or personal visit) any company, newspaper, book publisher, printer, art service, or sign shop. Let them know that you are available and show them samples of your work. Have a neat portfolio of samples for this purpose, but avoid repetition of the same styles; show variety. Make a select list of possible clients and contact them repeatedly with inexpensive photostats of your current work. Visit stationery outlets (department stores and printers) and offer a service of, for example, handwritten addresses on envelopes for invitations.

Following are some other uses for you to consider: T-shirts, company or club logotypes, monograms, signs, book jackets, greeting cards, names on mailboxes, certificates, diplomas, entire ads for stores, bookplates, shopping bags, bulletins, business cards, letterheads, place cards, name cards, packaging, forms, menus and inserts in menus, company newsletters, price lists, programs (music, drama, or other), directories (on walls near elevators), calendars, cookbooks, maps, poems and sayings, church programs, titles under photos in wedding books, wall signs, coat of arms and family trees, book markers, ex-libris designs, wallpaper (custom made), mailbox stuffers, envelopes, labels, invitations, record-album covers, TV titles for home videos, ceremonial scrolls, honor rolls, bumper stickers, gift wrapping paper for specialty stores, note papers, resolutions, memorials, dedications, testimonials, and many others.

Samples of three mailbox stuffers, original size 8½" × 11".

If there is no existing market for calligraphy in your locale, perhaps you can create one.

For limited amounts, you might learn silk-screen technique and print on shopping bags or T-shirts, for example.

If you are in a position to set up your own business, two free publications put out by the Internal Revenue Service will help. They are <u>Your Federal Income Tax</u> and <u>Tax Guide for Small Business.</u>

What to charge for your calligraphy is always a problem. The following comments may help you arrive at a fair price.

<u>First</u>, arbitrarily establish a per-hour rate.

<u>Second</u>, estimate how long it will take to do the job.

<u>Third</u>, multiply the two to arrive at a price. Include incidental expenses, such as mailing charges and cost of special materials, etc. If your final price is too high, you are either too slow or your per-hour rate is too high.

Wedding Invitations

The honour of your presence
is requested
at the wedding of

Retta Marie Beaty
and
David Lang Teeters

on the twenty-sixth of April
nineteen hundred and eighty six
at twelve noon
Walker Chapel
Arlington, Virginia

Writing all the copy for wedding
invitations, to be printed
later, is a service offered by
many calligraphers. A
minimum charge of $100 is a
fair price to charge for your
work, but this does not
include printing, envelopes,
etc.

Reception
immediately following
Walker Chapel

RSVP
4500 South Four Mile Run Drive
Apartment 830
Arlington, Virginia 22204

Reception card

Clients can be secured by reading the engagement notices in the social pages of your local newspaper. Church bulletins are another good source. Get in touch with the bride-to-be and show samples of your calligraphy.

Copperplate script is the traditional style, but other written styles, like the italic shown here, can be used.

If convenient, you will work with a local printer. Otherwise, just design the writing, and the bride's mother can take it from there.

Judith Hoffman
272 Oxford Ave.
Fair Haven, N. J.
07701

Writing names on envelopes is an extra charge — so much per envelope.

Business Cards

Judith Hoffman
Calligraphy
272 Oxford Ave.
Fair Haven, N. J. 07701

(012) 345-6789

Every calligrapher should have a card designed and written by him/her – they are little silent salespeople.

If you have a lot of copy, print on the back side.

Don't try to sell everything but the kitchen sink. Keep them simple and easy to read. Colored cards are O. K., but be sure you get good contrast with the color of the printing ink.

3½ inches by 2 inches is the size all business cards should be. Odd shapes and die-cut images that extend beyond the above measurements are to be avoided.

The most important elements are, in order, your name, your service, your address, and your phone number.

Printing in color is expensive. If you must use color, minimize the expense by using a color ink, a color card, or both.

Trouthe is
the hyeste
thyng that
men may
kepe." Chaucer

Keepsakes

In a world
where everything
is a copy...
I remain an
Original

Have a
Wonderful Day

Just as the warmth
of sunshine
Brightens the world
with flowers
The wonderful warmth
of friendship
Fills life with
happy hours.

Lettered over 2000
greeting cards for
Norcross / Rust Craft.

Joseph
Levine

Lettering for
blind embossed
letterhead.

Cover art
for greeting
card.

HAPPY BIRTHDAY, DARLING,

↳ Greeting card covers ⟶

Nice warm wishes always start

In a little corner of the heart

So teach us to number our days that we may apply our hearts to wisdom

psalms : 90,12

↳ Keepsakes ⟶

Acupuncture is a jab well done

Appointment Calendar

Title for calendar cover

Safety Precautions

Read labels on all products you buy for possible hazard warnings.

Always wash hands when finished working with paint, ink, or metallic powders.

————

If you smoke, keep burning objects away from flammable driers, rubber cement, and thinners.

————

Keep a pair of rubber gloves handy to use when you work with silk screens, refilling marker pens, etc. The gloves can also be worn to help open stubborn jar tops.

Keep your pen container away from a busy work area where pens may scratch skin or stick in your clothing.

————

Keep plastic bandage strips cotton swabs and balls, facial tissue, blotters, and liquid analgesic handy in the event you get a cut or there is some other accident.

————

Keep guards on cutting edges of sharp instruments when not in use.

————

Never put a pen or brush in your mouth. Some paints contain barium or lead and can cause serious health problems. Use saliva on a cotton swab or tissue to clean oil from new pen nibs.

Keep the room well ventilated when using spray fixatives, toxic cleaning agents, and solvents. Avoid breathing the fumes, and be sure to securely close tops when finished using.

Avoid rubbing your eyes with your fingers.

All scratch paper, used tape, and other waste should be put in wastebasket immediately.

Keep all food away from working area; you may spill it on artwork or contaminate the food with toxic materials.

If you use talcum powder, be careful not to inhale it.

Gum sandarac causes an allergic reaction in some people.

According to studies by the U.S. Public Interest Research Group in Washington, D.C., you must be careful if you are exposed to rubber cement, glazes, dyes, and paint, which may contain dangerous levels of hexane, toluene, lead, and cadmium. These chemicals may cause cancer, lung ailments, nerve disorders, and reproductive damage. Children are at great risk because of their small body size.

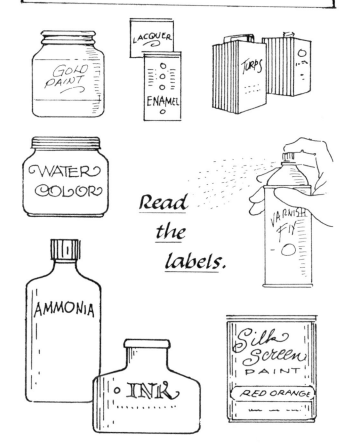

Read the labels.

115

If you work under fluorescent lights, wear a visor or peaked cap to protect your eyes.

Wear black or dark clothes when writing, or wear an apron or smock to protect your clothing from ink spattering or spilling.

Put jars of poster paint and ink on a small paper plate to catch potential drips.

Van Dyke Brown

Miscellaneous Tips

If you have trouble opening stubborn paint jar tops, turn the jar upside down and tap the bottom firmly with the palm of your hand. This may release pressure, allowing you to open the jar with ease.

———————

A small magnet attached to one end of a small stick will help pick up metal pens, pins, etc., that may drop on the floor.

———————

Patronize garage sales and buy the framed pictures the owner no longer wants. They are usually very low-priced. Later, dispose of the picture and save the frame for framing your calligraphy.

Use a small, folded card, as shown, for carrying pens in pocket, purse, etc.

———————

Excessive hot air in the room may cause ink to dry as you write. If you have this problem, a small pan of water on a radiator may help solve the problem.

———————

Large, flat boxes, like those photographic paper comes in, are great for mailing calligraphy.

Use a white wax candle (six inches by one inch) to rub over calligraphy written with water-soluble ink to waterproof it. Try it – it really works.

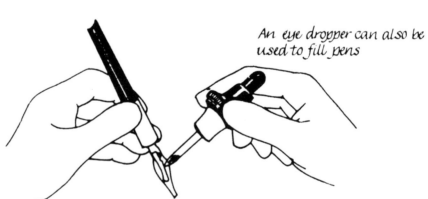

An eye dropper can also be used to fill pens

Use a pointed pen, or brush, to fill the reservoir of a pen instead of continually dipping it into the ink bottle. If you dip it, you will have to wipe the underneath part of the nib on a wipe rag before you start writing. Otherwise, you might get a blob of ink at the beginning. You will waste ink if you continually wipe after dipping.

Use a VA (Visual Art) form to copyright work. The forms are available from the Library of Congress in Washington, D.C. Keep accurate records of all expenditures.

An aid to learning a new style of calligraphy is to match a pen width of a dry pen to the heavy strokes on the model and write over the model without ink.

Keep small jars of paint flat on their sides in a small, flat drawer. Every time the drawer is opened and closed, the paint will be mixed. Be sure the tops are secure.

If you write calligraphy regularly for two or more clients, use different styles of writing for each. This will help readers identify each client easily.

Write for catalogues of art materials. Read the descriptions of the items - an education!

Sources of Supply

UK Suppliers

Falkiner Fine Papers Limited
76 Southampton Row
London WC1B 4AR
Telephone: 01 831 1151
Suppliers of calligraphy papers,
materials and books (including mail order)

Philip Poole
182 Drury Lane
London WC2B 5QL
Suppliers of pen holders and steel nibs
(including mail order)

The Universal Penman
9 Windmill Way
Tring
Herts HP23 4HQ
Telephone: 044 282 5503
Suppliers of quill pens and all calligraphic
materials (mail order only, no personal callers)

Rexel Limited
Gatehouse Road
Aylesbury
Bucks HP19 3DT
Manufacturers of pens and nibs (will supply
a list of local stockists on request)

Join a Society of Scribes

There are many writing organizations throughout the country whose purpose is to promote the learning and appreciation of calligraphy and related arts. Every calligrapher should join one and participate in the serious work of learning all he/she can about calligraphy through the workshops they offer, and should also enjoy the sociability that comes from sharing experiences. If geography prohibits you from attending meetings and functions in person, the material mailed (newsletters, bulletins) contains much valuable, useful information. Listed below are a few of these societies. Apologies are made herewith to those not included, but space limitations prohibit a full listing.

The Society of Scribes and Illuminators

Most serious calligraphers belong to this Society, which is open to anyone interested in promoting the aims of the Society. Benefits of membership include lectures, exhibitions and the use of the library, and the Society also publishes a journal three times yearly called The Scribe. For details of membership, contact the Honorary Secretary at 54 Boileau Road, London SW13 9BL.

Australian Societies and Suppliers

N.S.W.

The Australian Society of Calligraphers
P.O. Box 184
West Ryde, N.S.W. 2113

Supplier –
Willis Quills
164 Victoria Ave.
Chatswood, N.S.W. 2067 (shop and mail order) tel. no: (02) 411.2500

Victoria

The Calligraphy Society of Victoria
G.P.O. Box 2623
Melbourne, 3001

Supplier –
Calligraphy Centre
960 Whitehorse Road
Box Hill, Vic. 3128 tel. no. (03) 898.1101

Queensland

The Lettering Arts Society of Queensland
4/32 Gordon Parade
Mount Gravatt, Qld. 4122

Supplier –
The Pen Shoppe
Shop 59
The Myer Centre
Brisbane, Qld. 4000 tel. no. (07) 229.6944

Australian Societies and Suppliers (cont'd)

South Australia

The Calligraphy Society of S.A. Inc.
The Library
S.A. College of Advanced Education
Holbrooks Road
Underdale, S.A. 5032

Supplier –
Eckersleys
21 Frome Road
Adelaide, 5000 tel.no. (08) 223.4155

Western Australia

The Calligraphers' Guild of W.A.
101 Crawford Road
Maylands, W.A. 6051

Supplier –
The Creative Hot Shop
108 Beaufort Street
Perth, 6001 tel.no. (09) 328.5437

Tasmania

The Pen Script Society Tasmania
33 Melville Street
Hobart, 7000

Supplier –
Salamanca Place Gallery
65 Salamanca Place
Hobart, 7000 tel.no. (002) 23.3320

Australian Societies and Suppliers (cont'd)

A.C.T.

The Canberra Calligraphy Society
20 Brownless Street
McGregor, A.C.T. 2615

Supplier –
Swains
Shop 92A, Ground Floor
Belconnen Mall
Belconnen, A.C.T. 2615

tel.no. (062) 51.4764

Bibliography

Books on this and the next page are listed in no particular order.

PAINTING FOR CALLIGRAPHERS
Marie Angel
1984 Pelham

THE FIRST WRITING BOOK
John Howard Benson
1966 Yale University Press

PEN LETTERING
Ann Camp
1958, 1980 Black

THE CALLIGRAPHER'S HANDBOOK
Heather Child
1985 Black

CALLIGRAPHY TODAY
Heather Child
1979 Black

THE UNIVERSAL PENMAN
George Bickham
1941 Dover

THE BOOK BEFORE PRINTING
David Diringer
1983 Peter Smith (U.S.A.)

A BOOK OF SCRIPTS
Alfred Fairbank
1949, 1975 Faber

A HANDWRITING MANUAL
Alfred Fairbank
1932, 1975 Faber

CALLIGRAPHIC STYLES
Tom Gourdie
1976 Studio Vista

THE CALLIGRAPHER'S PROJECT BOOK
Susanne Haines
1987 Collins

THE STORY OF WRITING
Donald Jackson
1981 Black

WRITING AND ILLUMINATING & LETTERING
Edward Johnston
1977 Black

HISTORICAL SCRIPTS: A Handbook for Calligraphers
Stan Knight
1984 Black

THE CRAFT OF CALLIGRAPHY
Dorothy Mahoney
1982 Taplinger

THE ARTIST'S HANDBOOK of Materials and Techniques
Ralph Mayer
1981 Viking

ITALIC CALLIGRAPHY AND HANDWRITING: Exercises & Text
Lloyd Reynolds
1969 Taplinger

THE MYSTIC ART OF WRITTEN
FORMS
Friedrich Neugebauer
1980 Picture Book Studio (U.S.A.)

THREE CLASSICS OF
ITALIAN CALLIGRAPHY
ed. Oscar Ogg
1953 Dover

ADVANCED CALLIGRAPHY
Andrew Parkinson
1989 Phaidon

THE HISTORY & TECHNIQUE
OF LETTERING
Alexander Nesbitt
1950 Dover

WRITTEN LETTERS:
Thirty-Three Alphabets for
Calligraphers
Jacqueline Svaren
1986 Black

A MANUAL OF CALLIGRAPHY
Peter E. Taylor
1988 Unwin Hyman

CONTEMPORARY CALLIGRAPHY
Modern Scribes
& Lettering Artists, 2
1988 Trefoil

THE ART OF HAND LETTERING
Helm Wotzkow
1967 Dover

Index

About the Author

An artist and graphic designer, BILL GRAY is a recognized authority on calligraphy and type. He has taught at the School of Visual Arts in New York and at the Newark School of Fine and Industrial Art, designed for Promotion Design Associates and Norcross Greeting Cards, and previously published four other books of tips for designers.